05/07

UNIVERSITY OF
WOLVERHAMPTON

Harrison Learning Centre
City Campus
University of Wolverhampton
St Peter's Square
Wolverhampton WV1 1RH
Telephone: 0845 408 1631

Telephone Renewals: 01902 321333 or 0845 408 1631
Please RETURN this item on or before the last date shown above.
Fines will be charged if items are returned late.
See tariff of fines displayed at the Counter. (L2)

D1346494

URBAN IRAN

URBAN IRAN

MARK BATTY PUBLISHER – NEW YORK CITY

Urban Iran

All text © their respective authors.
All photographs © their respective photographers.
"Slab City," "Hair is for Head-Banging," "Roots of Rebellion" originally appeared in *Bidoun*.
Photo page 56 © Praveen Emmanuel
www.manuelfocus.com

Creative Director: Charlotte Noruzi
Design: Eliane Lazzaris
Production Director: Christopher D Salyers
Editing: Buzz Poole

Typefaces used: Mrs Eaves, Frankie Dos, and Estilo

Library of Congress Control Number: 2007937354

Printed and bound in China by Asia Pacific Offset

10 9 8 7 6 5 4 3 2 1 First edition

This edition © 2008
Mark Batty Publisher
36 West 37th Street, Suite 409
New York, NY 10018
www.markbattypublisher.com

ISBN: 978-0-9799666-1-3

Distributed outside North America by:

Thames & Hudson Ltd
181A High Holborn
London WC1V 7QX
United Kingdom
Tel: 00 44 20 7845 5000
Fax: 00 44 20 7845 5055
www.thameshudson.co.uk

IRAN

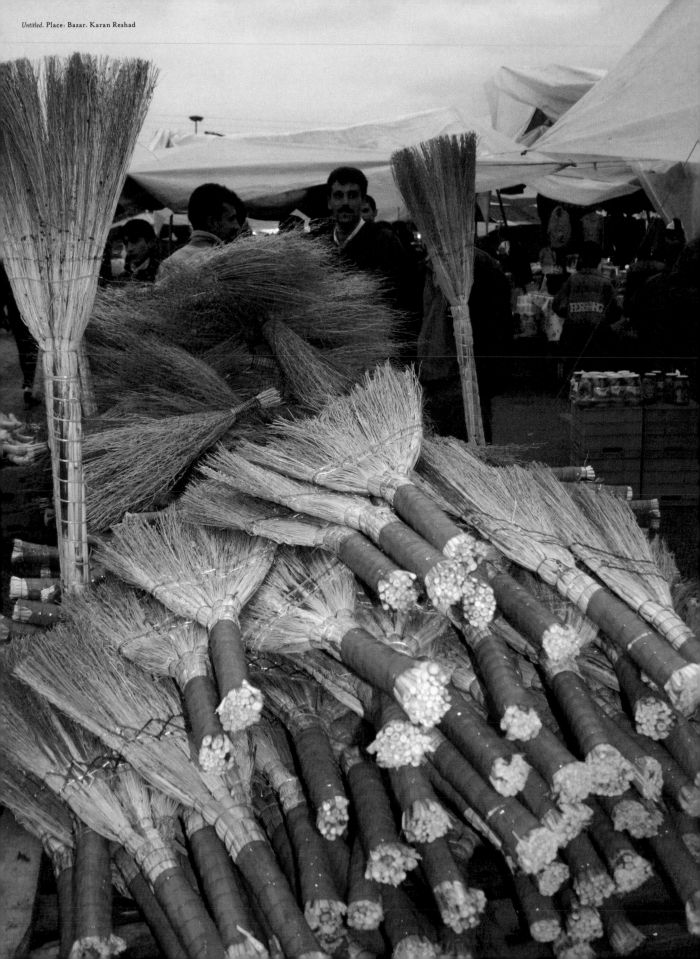

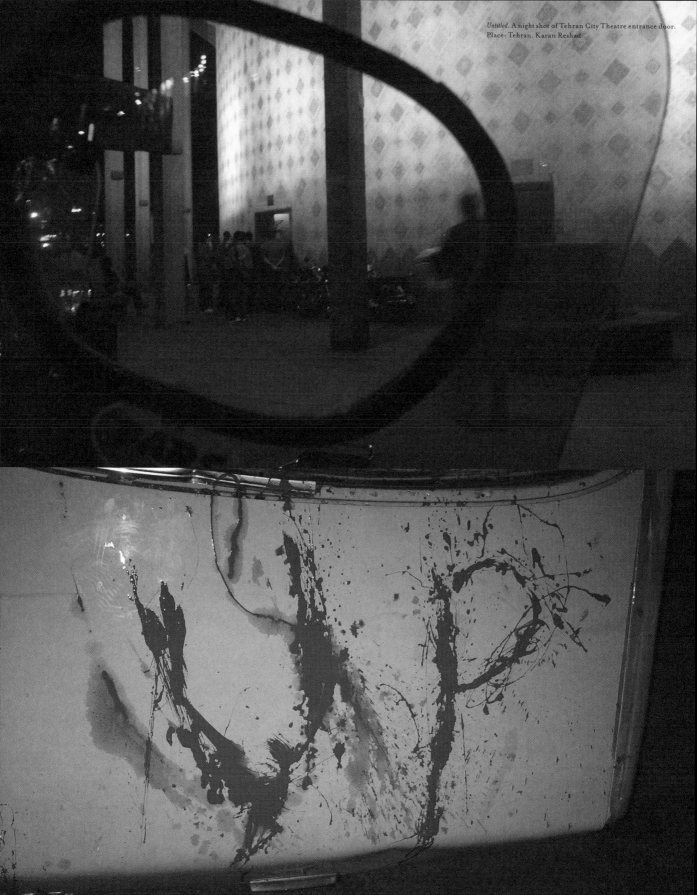

Untitled. A night shot of Tehran City Theatre entrance door.
Place: Tehran. Karan Reshad

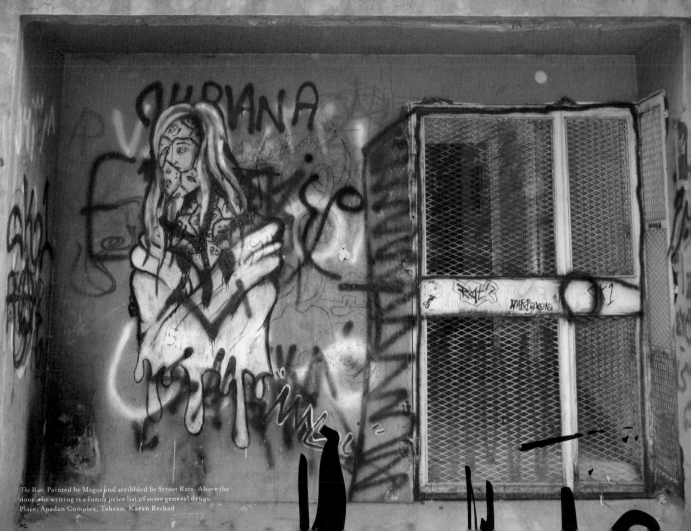

WELLCOME

تقسیم درب

طیبه اکجش دسیگاری وعلة قل بازان ۱۰۰۰۰

نوشابه ۱۰۰۰

آب: کفش را در بیارید ک ۵۰۰۰۰۰۰۰۰

کره ۲۰۰۰۰۰۰ وسرویس را بیگان در محل

OHRANA

The Man. Painted by Magoi and scribbled by Street Ratz. Above the door, the writing is a funny price list of some general drugs.
Place: Apadan Complex, Tehran, Karan Reshad

▽ CONTENTS

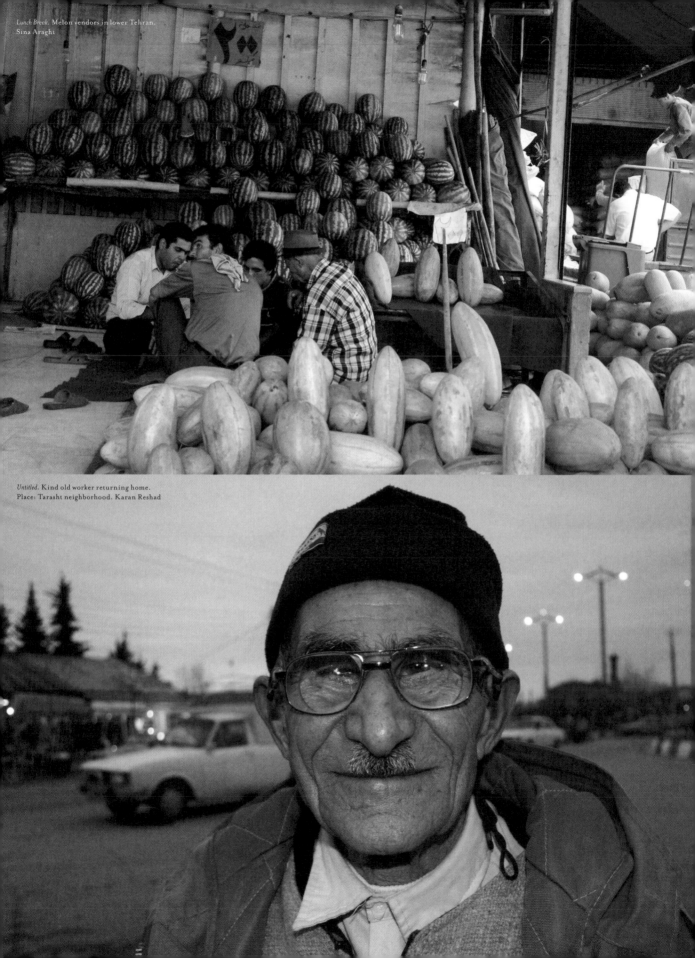

Lunch Break. Melon vendors in lower Tehran.
Sina Araghi

Untitled. Kind old worker returning home.
Place: Tarasht neighborhood. Karan Reshad

THE PHOTOGRAPHERS

Plug Yourself and Stay Safe. Works by Atone near the Caspian Sea.
Place: Ralesh Mahale/Rasht/Iran. Karan Reshad.

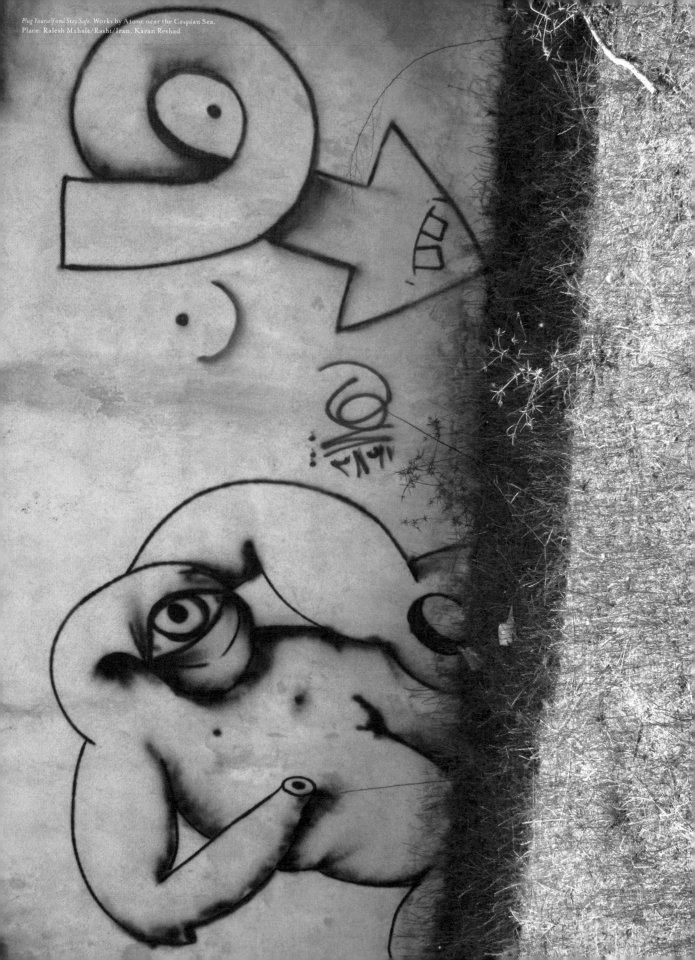

Karan Reshad

Karan Reshad is Tehran-based independent visual artist and documentary photographer. He started down this path in 1998, at the same time that he began a career as a graphic designer for various official Iranian magazines and advertising agencies. In 2002, a university committee dismissed him from the Azad Art and Architecture University of Tehran, for arguing with the Dean about Islamic limitations and obligations.

Realizing that the regimented worlds of school and office jobs were not for him, Reshad started his own design and visual arts studio: Kolahstudio. The downtown Tehran studio is "underground" in both the literal and figurative sense of the word; residing in a basement space its members create and showcase the best in contemporary Iranian and Middle Eastern art and design, while undermining the conformity of the mass media. Reshad actively pursues young artists, enlisting them in his effort to create an artistic renaissance through collaborative art and cultural exhibits, gatherings and performances.

As an aspect of this multifaceted effort, Reshad has been photographing Tehran's blossoming graffiti and street art scene since 2003. The subject of many of Reshad's photographs is the prolific A1ONE (see page 36), an artist who has clearly been inspired by the traditional tools of graffiti and street art, but takes his work to another level by infusing it with the rich cultural heritage of Iran and the trappings of contemporary geo-political realities. Aside from street art, Reshad also trains his lens on the day-to-day activities of Tehran's bustling streets, as well as the activities that go on after the sun has set, providing intimate and revealing portraits of everything from street markets to rock 'n' roll.

Beyond his interests in the visual arts, Reshad has also been involved with publishing endeavors, the most interesting being *Turn Up the Night*, a translation of Black Sabbath lyrics from English to Persian that included an overview of heavy metal

(Continued on page 16)

13

"RESHAD EMBODIES URBAN IRAN, CELEBRATING IT AND CRITICIZING IT SIMULTANEOUSLY, AND THAT SEEMS TO BE THE ESSENCE OF THE COUNTRY TODAY. OF COURSE, THERE IS NOTHING NEW ABOUT SUCH A RELATIONSHIP, BUT THAT'S THE ULTIMATE POINT. IRANIANS ARE NOT JUST SOME AGGREGATE, ITS PURPOSE TO SERVE AS NOTHING MORE THAN MEDIA HEADLINES AND STATISTICS FOR GOVERN-MENT REPORTS. THEY ARE INDIVIDUALS, STRUGGLING AND ENJOYING LIFE THE BEST THEY CAN, THE SAME AS THE REST OF US."

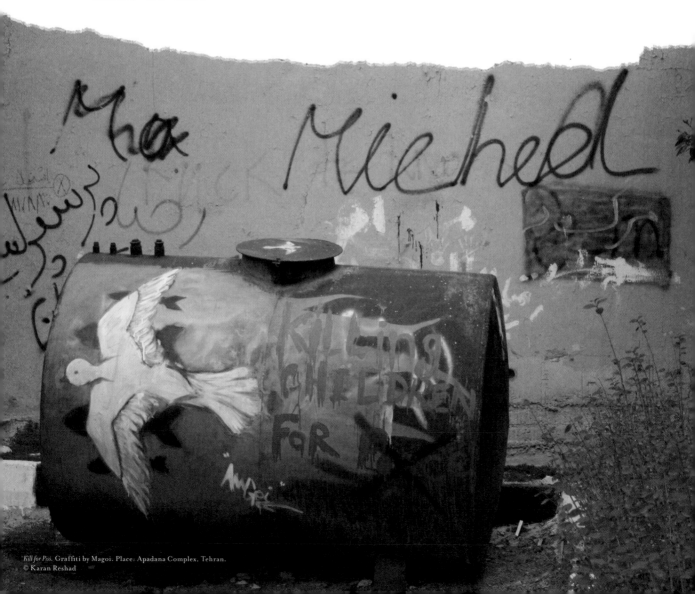

Kill for Piss. Graffiti by Magoi. Place: Apadana Complex, Tehran.
© Karan Reshad

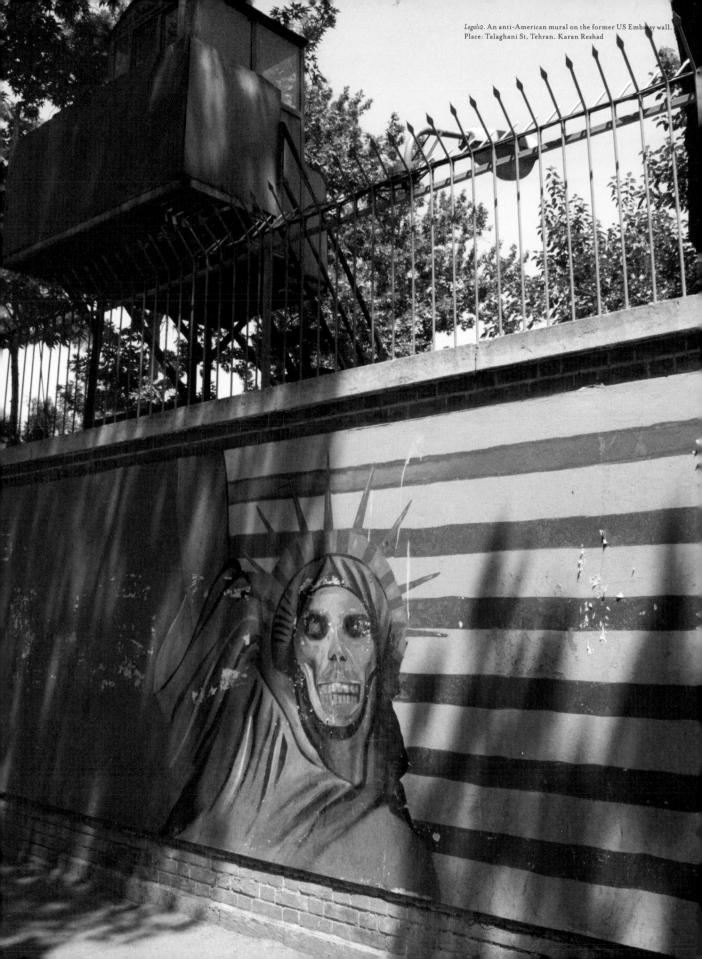

Legals2. An anti-American mural on the former US Embassy wall.
Place: Talaghani St, Tehran. Karan Reshad

music and its subgenres (touching on bands like Led Zeppelin, Nirvana and Marilyn Manson). It was published in 2001 by Mess Publications, a publishing house that had started during the administration of President Mohammad Khatami (1997-2005). During that time, according to Reshad, "government censorship had lessoned a bit." Mess Publications used this easing of censorship as an opportunity to publish Persian translations of lyrics written by some of the world's most famous rock 'n' roll and heavy metal bands. The censorship laws changed, however, when President Mahmoud Ahmadinejad took office. The first printing of the 600-page *Turn Up the Night* (3,000 copies) had sold out by the time Ahmadinejad took office and when Mess Publications tried to obtain permission to reprint the book, the new government denied the request. (For more about the state of publishing and censorship in Iran, see page 87.)

Karan Reshad stands at an important intersection of the arts in Iran, as a proud Iranian and a member of the internet's far-reaching landscape that shrinks the world, exposing many of its undesirable blemishes. From graffiti to heavy metal, from publishing to advocating art, Reshad's experiences weave in and out of all the stories told in this book. He embodies urban Iran, celebrating it and criticizing it simultaneously, and that seems to be the essence of the country today. Of course, there is nothing new about such a relationship, but that's the ultimate point. Iranians are not just some aggregate, its purpose to serve as nothing more than media headlines and statistics for government reports. They are individuals, struggling and enjoying life the best they can, the same as the rest of us. ◉

16

Words by Buzz Poole

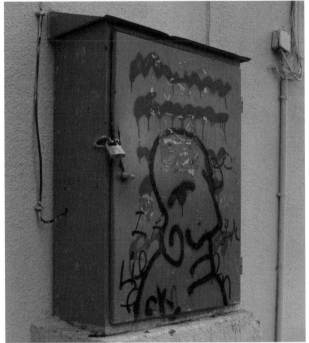

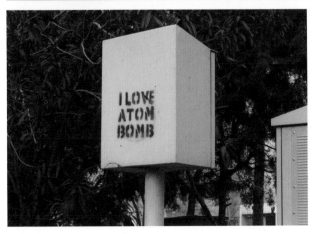

Top: *Untitled*. Work by CK1 on urban box. Place: Apadana Complex, Tehran. Karan Reshad
Bottom: *I Love Atom Bomb*. Stencil by A1one, poking fun at Iran's role as a nuclear power.
Place: Apadana Complex, Tehran. Karan Reshad

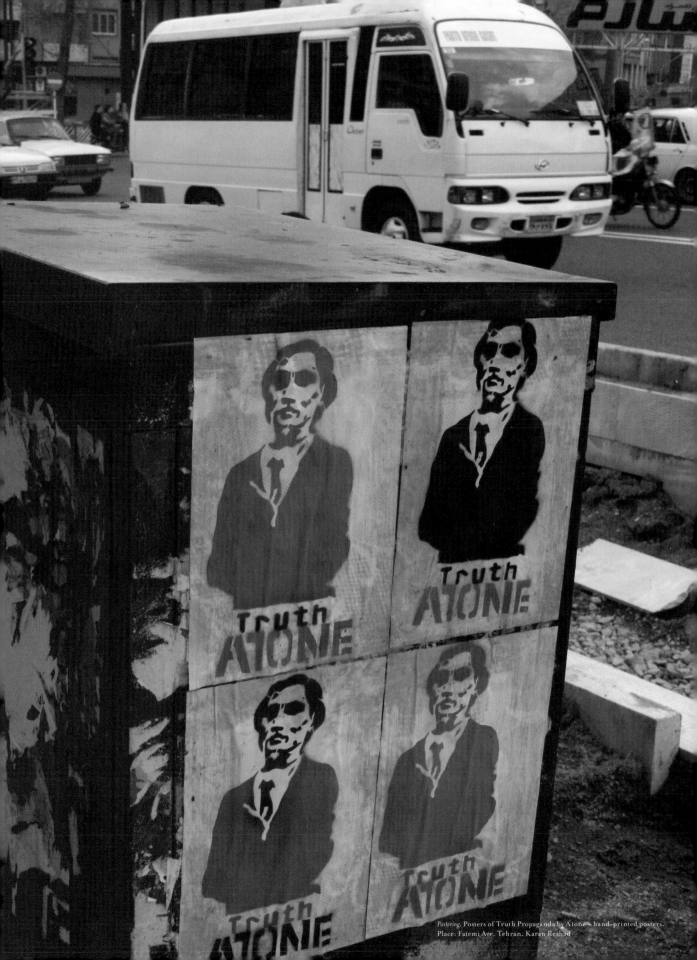

Postering. Posters of Truth Propaganda by A1one – hand-printed posters.
Place: Fatemi Ave. Tehran. Karan Reshad

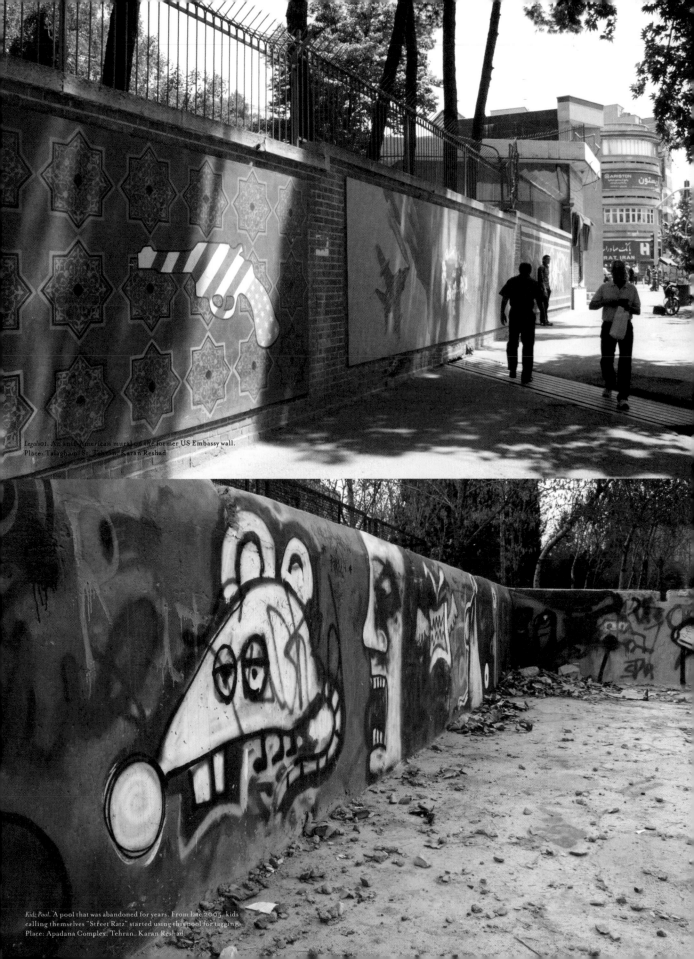

Legals01. An anti-American mural on the former US Embassy wall.
Place: Talaghani St. Tehran. Karan Reshad

Kidz Pool. A pool that was abandoned for years. From late 2005, kids
calling themselves "Street Ratz" started using this pool for tagging.
Place: Apadana Complex. Tehran. Karan Reshad

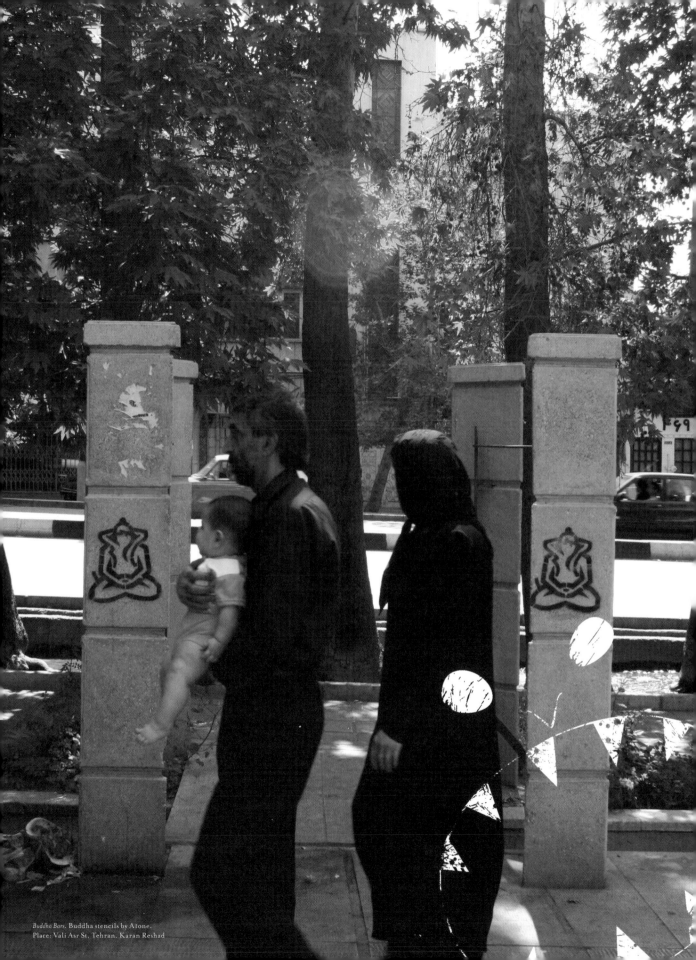

Buddha Bars. Buddha stencils by Atone.
Place: Vali Asr St. Tehran. Karan Reshad

Ent. Place: Velenjak, Tehran. Sina Araghi

20

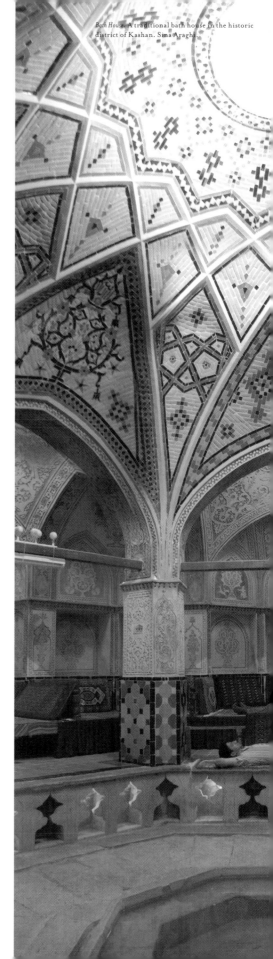

Bath House. A traditional bath house in the historic district of Kashan. Sina Araghi.

FROM THE INSIDE TO THE OUTSIDE

Sina Araghi

First, let me begin by telling you that I was born in 1981, two years after the revolution and memories of my childhood in Iran are from the 8 years of war that the country was engaged in. I don't really remember being exposed to any kind of art during those years, with the exception of bootleg American movies (i.e., *Footloose* and *Goonies*) and popular Iranian and American music (Michael Jackson, Prince, Googoosh, Shahram Shapare). Not very culturally enriching, but from what I can gather, most people didn't have the luxury of a clear state of mind to focus on such things. Food was being rationed, electricity constantly cut off and air raids rattled our homes and our nerves. I was still a child, but it seems to me as though the arts in Iran were silenced to a great extent in the first 10 years after the revolution, partly because many of the artists that existed before the revolution were either suppressed by the new government or had fled the country.

What we are experiencing now is a re-emergence of art in Iran. We have a large population of youth, who like myself, were born after the revolution, and for those who stayed in the country, they have only known one kind of life under the new regime. And now this generation has reached an age where they can sort of make sense of their environment and express their thoughts in many creative ways such as we've been seeing for the last five or six years. This new generation not only has a lot on their minds, but it also knows how to get around government controls in order to get messages out.

I went to Iran in the summer of 2006. I knew that I wanted to see more of the country than what I had been exposed to as a child. I needed to see what the rest of the country was like, outside of Tehran. My road trips took me to the Gilan and Mazandaran Provinces that lie along the Caspian coast, from tourist resorts to vast fields of rice paddies and villages high up in the mountains where locals speak a dialect that is partially Turkish. Another leg of this trip took me west to Kermanshah and Kurdistan, from industrial towns to Sufi holy sites, from flat

(Continued on page 24)

"Tehran is a different story. The environment really does shake the senses. The large crowds. The lack of order and respect for one another. The mind numbing traffic and almost lawless sense of driving are elements that are difficult to prepare for when visiting. And yes, the people are, as a whole, angry. They are under tremendous stress everywhere they go. They have no faith in the government and have no reservations about expressing their frustrations. And the youth try to make the best of what they have: a shortage of jobs, limited freedoms, closed off from the world, under constant pressure from authority."

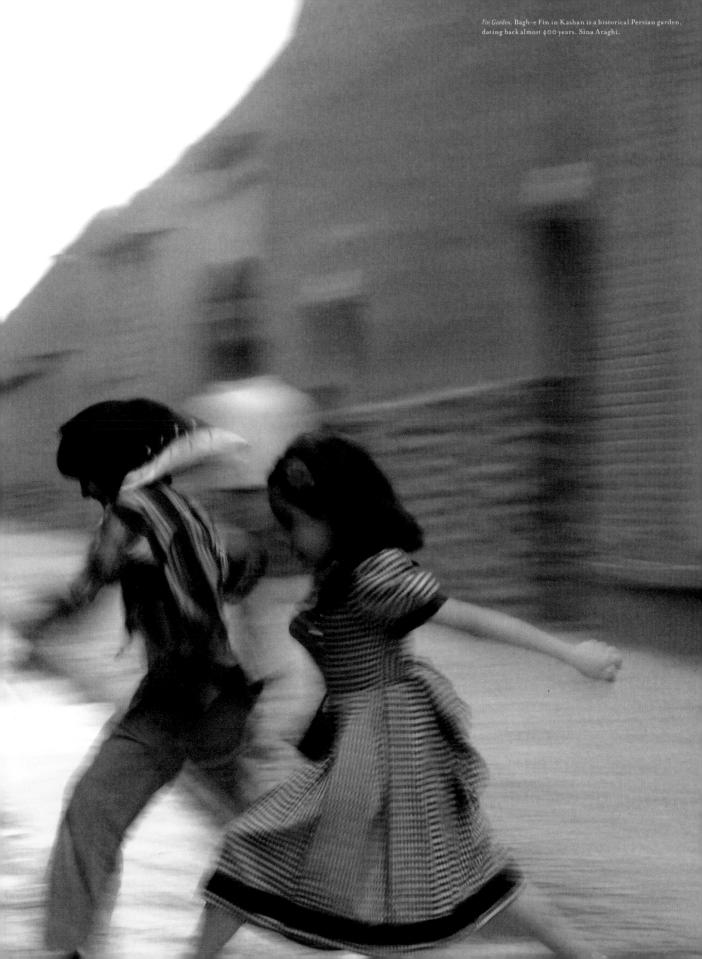

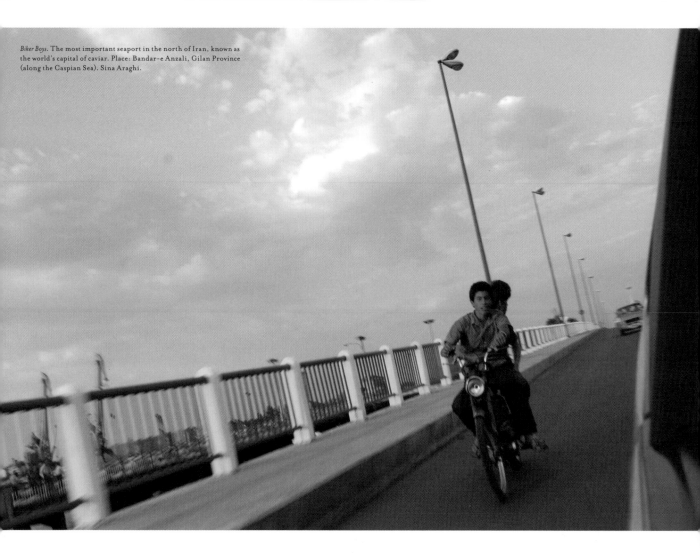

open country to mountainous regions a short drive away from the Iraqi border and into the homes of wonderfully warm and hospitable Kurdish families. I went into central Iran and the historic town of Kashan with its amazing desert architecture, and later on to the Island of Kish, a luxury resort that could have been, but never was. I was astonished to witness and experience Iran's cultural diversity; amazed that such a large variety of cultures could live under the umbrella of one nation. No one had ever told me, amazingly enough, that Iran was made up of such different people who carry with them many histories and cultures, languages and religions vastly different from the notions outsiders have about what it means to be Iranian. It really brings to question what it means to be an Iranian. These differences were giving me difficulty as I tried to make sense of my Iranian/American identity.

Tehran is a different story. The environment really does shake the senses. The large crowds, the lack of order and respect for one another, the mind numbing traffic and almost lawless sense of driving are elements that are difficult to prepare for when visiting. And yes, the people are, as a whole, angry. They are under tremendous stress everywhere they go. They have no faith in the government and have no reservations about expressing their frustrations. And the youth try to make the best of what they have: a shortage of jobs, limited freedoms, closed off from the world, under constant pressure from authority.

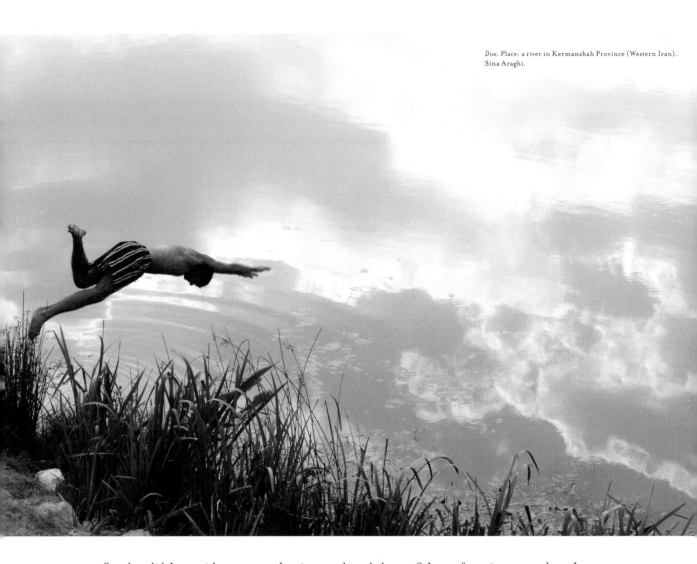

Dive. Place: a river in Kermanshah Province (Western Iran).
Sina Araghi.

So what did I see with respect to Iranian youth and the arts? Lots of music – everywhere I went, music was very prevalent. There is a resurgence of classical Persian music among the youth. Sufi music, poetry and art are very popular; I think partly because the government is more lenient with this form of art, in addition to the fact that Sufi poetry has gained popularity around the world in recent years. Underground hip-hop is another style of music with surprising popularity. These live shows reminded me of the underground rave scene of the 1990s in the US. Now, fortunately, with the help of Youtube, a lot of these groups can expose themselves to a larger audience outside of Iran. The band Kiosk (although not hip-hop) is probably one of the best examples of a band that has been able to find success abroad through their music videos posted online.

Of course, film and photography are also flourishing in Iran, too, and the work is very socially conscious. It's easy to see how much symbolism is used in films and photographs that are created in Iran today. There is no art for art's sake, in that there are few patrons. The youth in Iran have a lot to express these days. They use art as a way to channel their thoughts, anxieties and, at times, frustrations – and for that, art in all of its forms serves a great purpose in today's Iran. ◉

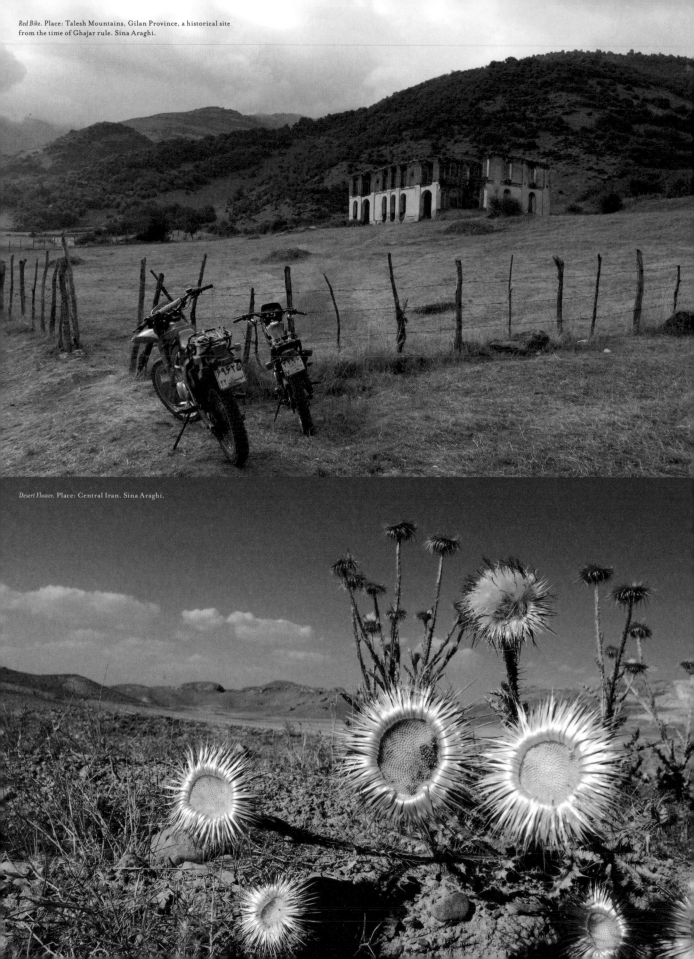

Red Bike. Place: Talesh Mountains, Gilan Province, a historical site from the time of Ghajar rule. Sina Araghi.

Desert Flower. Place: Central Iran. Sina Araghi.

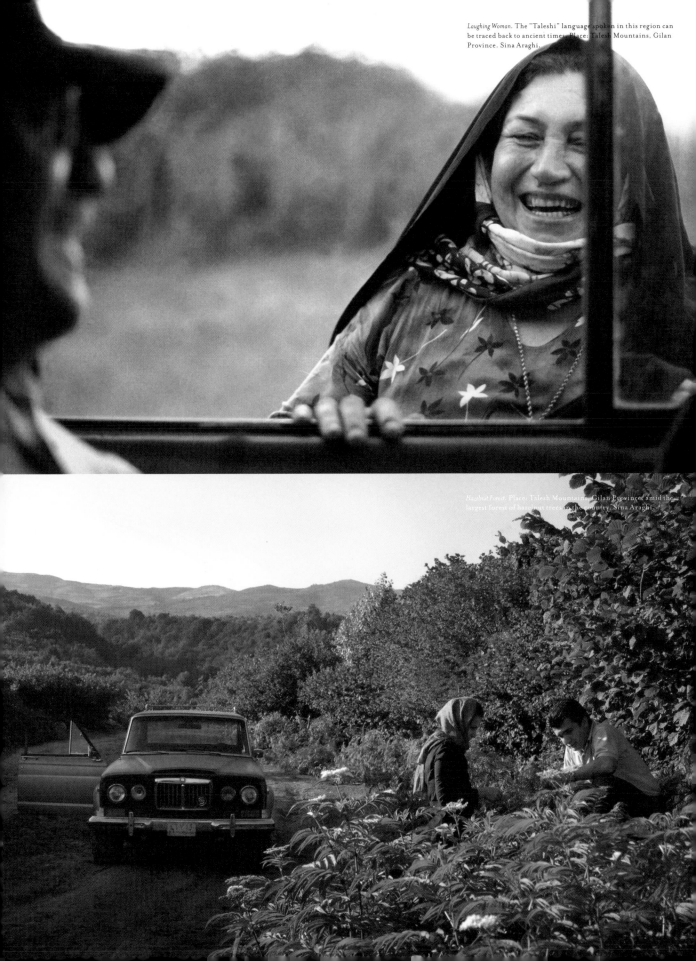

Laughing Woman. The "Taleshi" language spoken in this region can be traced back to ancient times. Place: Talesh Mountains, Gilan Province. Sina Araghi.

Hazelnut Forest. Place: Talesh Mountains, Gilan Province, amid the largest forest of hazelnut trees in the country. Sina Araghi.

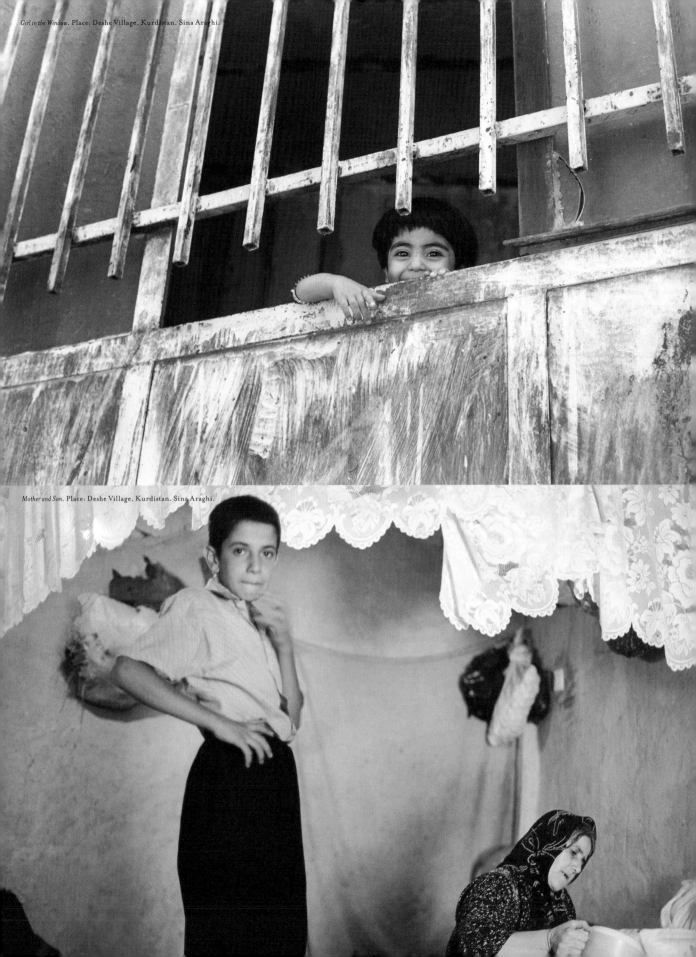

Girl in the Window. Place: Deshe Village, Kurdistan. Sina Araghi.

Mother and Son. Place: Deshe Village, Kurdistan. Sina Araghi.

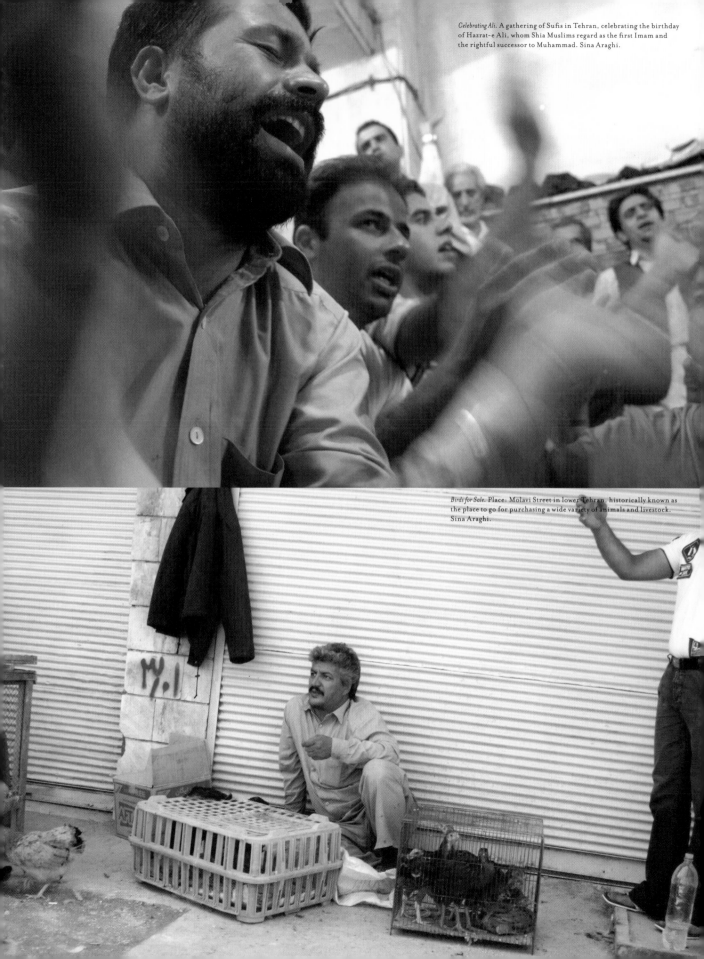

Celebrating Ali. A gathering of Sufis in Tehran, celebrating the birthday of Hazrat-e Ali, whom Shia Muslims regard as the first Imam and the rightful successor to Muhammad. Sina Araghi.

Birds for Sale. Place: Molavi Street in lower Tehran, historically known as the place to go for purchasing a wide variety of animals and livestock. Sina Araghi.

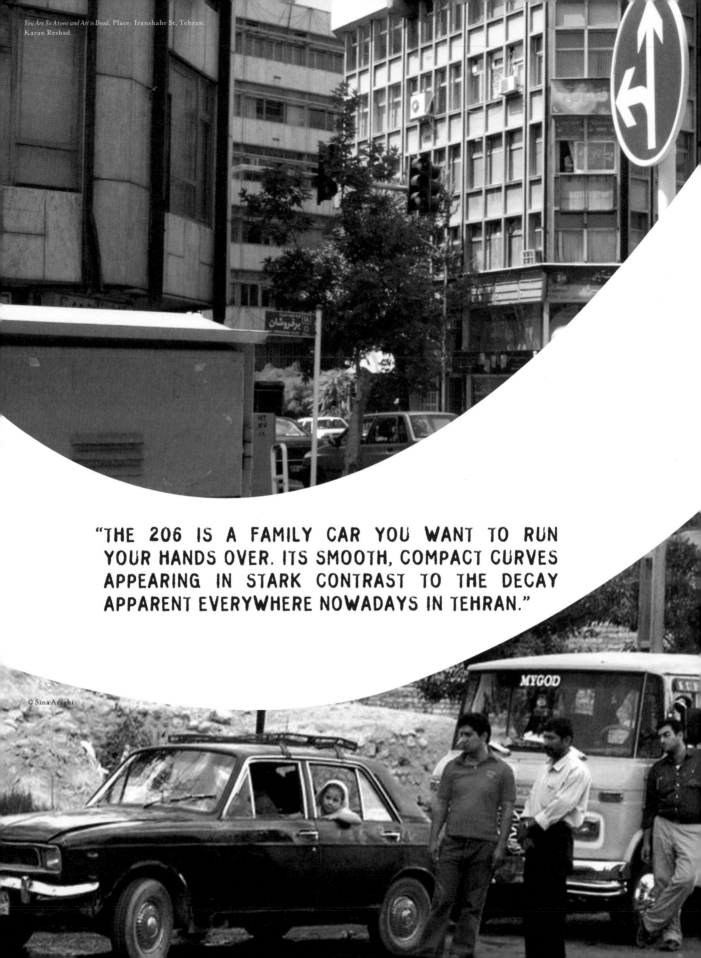

You Are So Alone and Art is Dead. Place: Iranshahr St, Tehran.
Karan Reshad

© Sina Araghi

"THE 206 IS A FAMILY CAR YOU WANT TO RUN YOUR HANDS OVER. ITS SMOOTH, COMPACT CURVES APPEARING IN STARK CONTRAST TO THE DECAY APPARENT EVERYWHERE NOWADAYS IN TEHRAN."

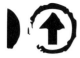

the 206

JALAR ABDOH

The tougher road from Tehran to the southern Caspian shore is also the most spectacular. Not a road for the faint of heart, I decided not to take it, and rather chose the more manageable "highway" that passes through the city of Qazvin — a town with the dubious distinction in Iranian lore of being an incorrigible nest of pederasts. I drove in a white Peugeot 206, an obliquely sexy, yet demure, French hatchback that has been copied and assembled in Iran in recent years. The 206 is a family car you want to run your hands over. Its smooth, compact curves appearing in stark contrast to the decay apparent everywhere nowadays in Tehran. The car hints of progress and sanity; you want to ride the damn thing right into the future, flushed with a bit of Persian pride every bit of the way.

But on the Qazvin road that day pride wasn't what immediately came to mind. Rather, I was feeling the squeeze of driving in a country that passes traffic laws only to mock them. The 206 ran smoothly enough, but the road didn't. After all, no matter which route you take to the north, there comes a moment when the mountains will have to be negotiated. And it was during this phase of the drive that I found myself in the middle of a car chase in the hairpin landscape. If my car was a bride, theirs was an old maid, a faded blue British Hillman clone that must have seen its last good days thirty years ago. But it did house five men, tough operators, bearded and black-shirted, who looked like they owned the road. They did own the road, it just took me a while to find that out. The first time they pulled past and swerved inside to block my way, I thought they were kidding around. The second time, I thought that no, they were in fact quite serious and meant to push the 206 and me off the cliffs. The third time, I just about found religion; this was a death chase and I was by far the lesser driver. Their clunker kept catching me no matter how hard I drove the 206. After about twenty minutes of this cat and mouse — an eternity under the circumstances — I began to feel sorry for myself and resigned to fate: somewhere in the mountains of the north I was going to be pushed off the road and be done away with. And for what? If I were lucky, they were only after the borrowed 206 I was driving. At some point a police Mercedes barreled the other way and it didn't dawn on me until a second later that I should have put the brakes on and cried for help. I decided to chance a last attempt at escape, but this time when the blue car came up parallel one of the men in the backseat was flashing a semi-automatic out of the window. The gun wasn't directed at the 206, but dangled from the man's hand directing me to pull to the shoulder. I did.

They were roadside undercover cops. This was a delayed realization and it only came when the gun was flaunted. I knew that had the gunman been a bandit he would not have held onto the piece so casually. Nevertheless, the knowledge that these fellows were police brought little relief. We were in the thick of summer and the Islamic Republic was in the midst of one of its laborious "morality campaigns." This entails stopping cars to search for contraband like alcohol, looking for signs of improper dress and checking to make sure that men and women driving together are related by blood or marriage. It's probably best not to insist on your rights when a morality campaign is in full swing. I had forced these guys to give chase on a dangerous stretch of the mountains, and if anyone was more angry than me at that moment it was they. On the other hand, I wasn't carrying contraband, I was properly dressed – a simple long sleeved white shirt and a serviceable week-old beard – and I didn't have a woman with me.

So I decided to give them a spiel, because, I suppose, that's what a fellow does when facing five black-shirted bearded men who carry semis in the mountains near Qazvin. Brothers, I gave my blood, and much of my hair, for every inch of these peaks. I was taking Iraqi shrapnel during the war while you gentlemen were still in your swaddling clothes. Would God be pleased if he saw what a scare you just gave me? I could have died. We all could have died. A minute into my absolutely false rant and before they ever had a chance to ask to see my driver's license, I saw that they were hesitating between contrition and feeling downright sorry for me. Nor did it hurt that somewhere in the middle of this protest I happened to mention the half-truth about being headed to the city of Ramsar to see my good friend, Police Colonel A. H.

This had been a 007 sort of chase executed in a 206. And I never figured out what these men truly wanted. They'd told me vaguely that they were in the middle of an operation and they were sorry if they had inconvenienced me. Fair enough. But was there something so incongruous about my driving a 206? I was pretty shaken and suspicious of just about every car I passed the rest of the way north. In Ramsar I didn't go to see the Colonel, but headed to the villa of a real estate developer I knew, J.C. You enter a place like J.C.'s and it's as if time had stopped circa 1975 and the Islamic revolution had never happened. Immaculately trimmed palm trees line a driveway that runs a straight path to the beach, a red asphalt tennis court sits at one end of the place and a swimming pool at the other; the bar is hugely stocked with every kind of banned liquor you could imagine; the local groundskeeper and his family come and go as if the stripped-down men and women from Tehran up here for a little water skiing and a lot of sun-tanning were the most normal occurrence in the Islamic Republic.

This split in the personality of the country is in fact what makes Iran so difficult to describe to non-Iranians. Two entirely parallel worlds exist side by side – the world of interiors, and the world outside. Trouble of course comes when one of these worlds starts to lean on the other. For instance, just five-hundred yards outside of J.C.'s villa that day there had been a roadblock that I'd been lucky enough to miss after my ordeal with the undercover cops. But a couple who had driven from the town of Nur some one-hundred kilometers on the coast road were not so lucky. The man had nearly been strip-searched while his wife had had to hide their hard-bought bottle of red wine by shoving it up her skirt. They were as pale as ghosts when they drove through the green gate in their black Peugeot 206. It was not a good

day for this model car, I thought. Needless to say, to calm the nerves — what between my story and theirs — we consumed plenty of illicit liquor that night.

Two days later back in Tehran I caught up with 127, an Iranian underground rock

"THIS SPLIT IN THE PERSONALITY OF THE COUNTRY IS IN FACT WHAT MAKES IRAN SO DIFFICULT TO DESCRIBE TO NON-IRANIANS. TWO ENTIRELY PARALLEL WORLDS EXIST SIDE BY SIDE — THE WORLD OF INTERIORS, AND THE WORLD OUTSIDE."

band whose lead singer and songwriter, Sohrab Mohebbi, had his own 206 story — a story that he also wrote to me at some length about later on. The story goes something like this: recently an international art journal had commissioned twelve Middle Eastern artists to present some of their work. Sohrab, who also writes art criticism, had suggested one of Iran's bright young artists, Rokni-ed-din Haer-izadeh for the project. According to Sohrab, this is what occurred:

Inspired by the latest attack of the "fashion police" in the streets of Tehran, Rokni had already created three, 2 by 2 (meters) acrylics on canvas titled "Passage." When Rokni sent in the first drafts of his works, the editor sounded a bit unsatisfied and complained about what she called the "futuristic" cars in his work and preferred to omit them. For starters, Rokni's so-called futuristic car was nothing more than the regular Peugeot 206, one of Iran's most commonplace middle-class economy cars, an icon of modernized Iran and the symbol of our technological progress and independence. This car is obviously a French design, but it is assembled in Iran, and its outlines are known to just about every Iranian. In fact, the 206 is so ubiquitous here that I feel safe claiming the average Iranian can draw the thing blindfolded.

In short, for both Rokni and me the 206 summed up a lot of our country's dilemmas. But to the editor, the car appearing too "modern," she preferred at first to leave it out of the project. The episode really left its mark in my mind and I have not ceased thinking about it as an example of all the misunderstandings that occur between East and West, or what I would call "the persistence of misinterpretation in reading through images between us and them."

I thought: this summer of the fashion police has coincided with the curse of the 206. Like Sohrab, who could not get the story of the 206 vis-à-vis the art journal out of his head, I could not forget the car chase I'd experienced on the Caspian road. The 206 was Iran in all its glorious impenetrability. And for the time being I wanted no part of it — the 206, I mean. I'd stick to my 125 cc Honda clone motorbike, which gave me the appearance of a lowly, invisible messenger boy no one would want to glance at a second time. I even developed a new spiel because of this: one night, after coming out of 78, a café/gallery in the heart of the city frequented by Tehran's hipster set, I realized the bike was not going to start. A semi-crooked bike mechanic I knew happened to own a hole-in-the-wall shop not too far off on North Bahar Street. I had already decided to push the bike to the mechanic's place, leave it outside and just deal with the whole thing in the morning. But then, a roaming van driver who was parallel parked across the street smoking a cigarette asked if I needed the bike hauled.

"How much for the haul?"

"Not much," he says, "eight thousand tuman."

"Are you serious? Eight thousand? What do you think I own, a 206?"

"Well, you did just come out of 78, didn't you? I hear they charge 3,000 for a cup of coffee. That's a joke."

"Look at me, brother, I only ride a 125. Not a 206."

The man halved his price before he finished his smoke, and then took another thousand off of that, so that I ended up only paying 3,000, the price of an espresso at Café 78 — and this only because I rode a humble 125 and not a pristine 206.

After I'd chained the bike on North Bahar, I walked back over to The 7th of Tir Square, which before the revolution used to be called The 25th of Shahrivar Square. I planned to take the metro from there uptown. But seeing a motorcycle cab waiting around I decided to take a chance.

"How much to Yusefabad?"

"3,000."

And the haggling started. Thinking I had my finger on the pulse of something, I did my little dance about how I wasn't a driver of a 206, was I? And by God if I had money, I'd buy myself a car instead of flagging motorcycles down. Therefore: "What I require, brother, is a steep discount." For I was a humble rider of a 125 myself. The thing had broken down on me and no doubt I would have to give the last of my cash to some crooked mechanic on North Bahar in the morning.

"Come, let us have the discount, comrade. Yusefabad is a quick breeze on the freeway."

I had expected the man to relent. Instead, tears welled in his eyes and he just about told me to get lost.

I was unsettled. "What, did I say something wrong?"

He was a middle-aged fellow who I imagined had turned prematurely grey before he was twenty. He was long in the face, crushed and sooty, the look only a motorcycle guy who has to eat the exhaust fumes of Tehran can possess. He told me he'd signed up for a spanking new 206 over two years ago and was all set to finally get his dream car. But his dreams were dashed when he'd hit a pedestrian with his bike four months earlier and had had to shell out every last coin he'd saved or go to jail. "Life's not fair, brother," he said. "The 206 is a classy car, I could have made a good living off of it." He meant he could have been taking four passengers at a time in his luminous 206 instead

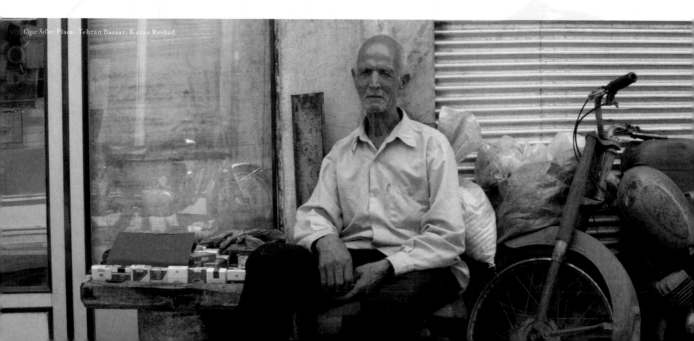

Cigar Seller. Place: Tehran Bazaar. Karan Reshad

of single rides like me on the back of this crumbling bike. That was why he wanted no part of my stinginess. I agreed to the 3,000.

I sat on the back of that bike and wondered if I'd been had, if this man hadn't worked out a better story than I had. And then it didn't matter. I was tired and at least the man didn't steer his bike like a maniac, which made the ride almost worth the 3,000. We coasted up Moddares Freeway and somewhere along the bend from Moddares to Martyr Hemmat Freeway we passed an accident. Two young women stood outside of a red 206 and its badly dented passenger door. They gazed away with impassive eyes from the scene of the crash at the dry hills to their right. They looked misplaced and unhappily juxtaposed here. The evening traffic wired around them and curious eyes briefly gawked in their direction. A big man stood between the 206 and the car that had hit them. He was talking angrily on his cell phone. The other car was another one of those old, ubiquitous Hillman

"THE EPISODE REALLY LEFT ITS MARK IN MY MIND...AS AN EXAMPLE OF ALL THE MISUNDERSTANDINGS THAT OCCUR BETWEEN EAST AND WEST, OR WHAT I WOULD CALL 'THE PERSISTENCE OF MISINTERPRETATION IN READING THROUGH IMAGES BETWEEN US AND THEM.'"

clones that had chased me on the Caspian road. The front of this car looked just slightly bent out of shape, but the front window had deep cracks in it. A lone young man sat at the driver's seat, his head resting on the steering wheel, crying. I'd say he was crying with a bit of exaggeration; the man seemed to want the whole world to know he was crying.

As we left them behind — the crying man and the angry man and the dazed women — I wondered about each of their stories. Why, for instance, was that fellow bawling like that? Had he signed up for a 206 too, only to see his ambition smashed now that he'd been in an accident that was probably his fault? And what of the angry man on the cell phone and the dazed women? What of their damaged, obscenely, ferociously red 206 sitting askew under the freeway lights? And what of this fellow charging me 3,000 tuman for the ride on his 125? Tehran stories they were. Lives of modest tragedy revolving around something as dull as a 206. A car that was so much a part of this landscape and wasn't. ◉

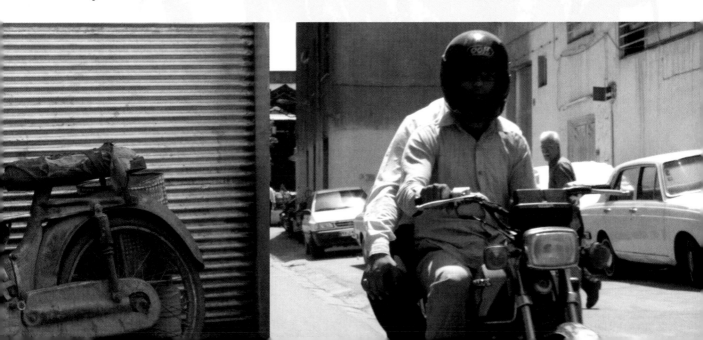

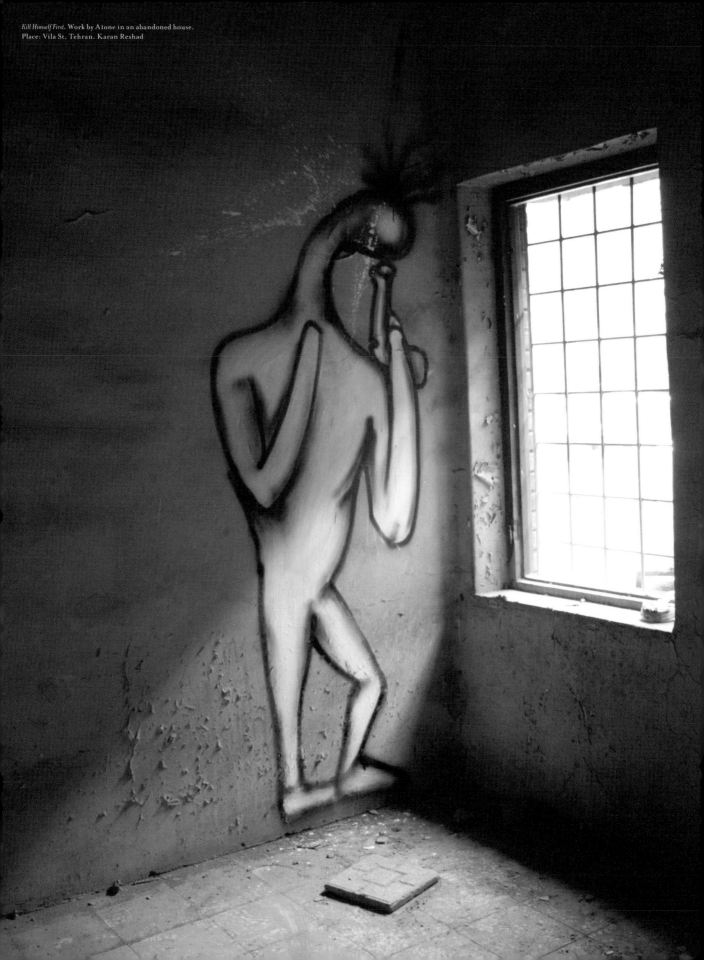

A1ONE

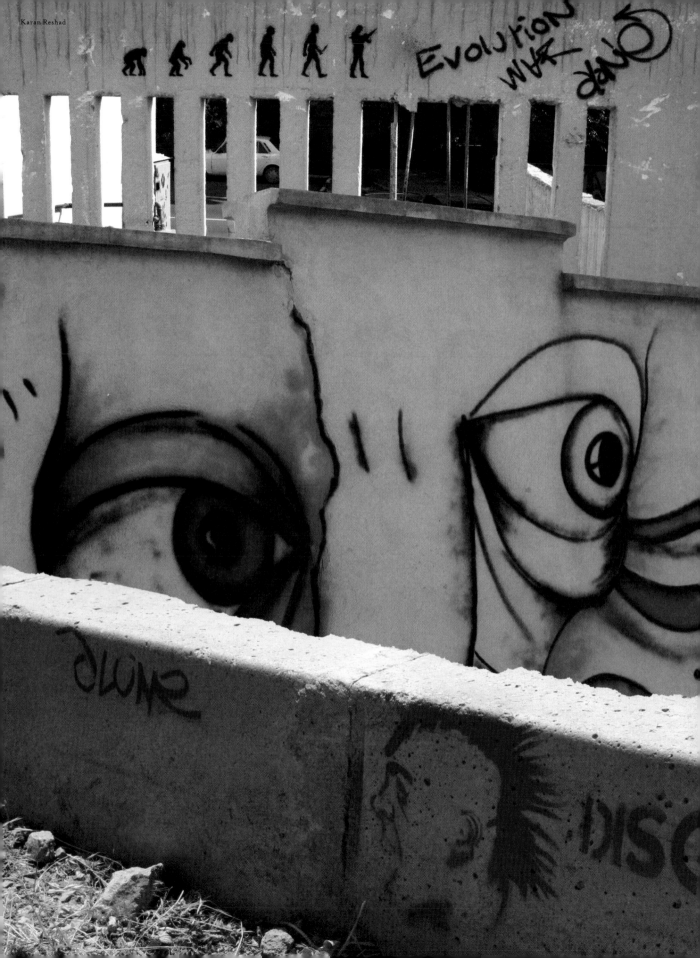

Karan Reshad

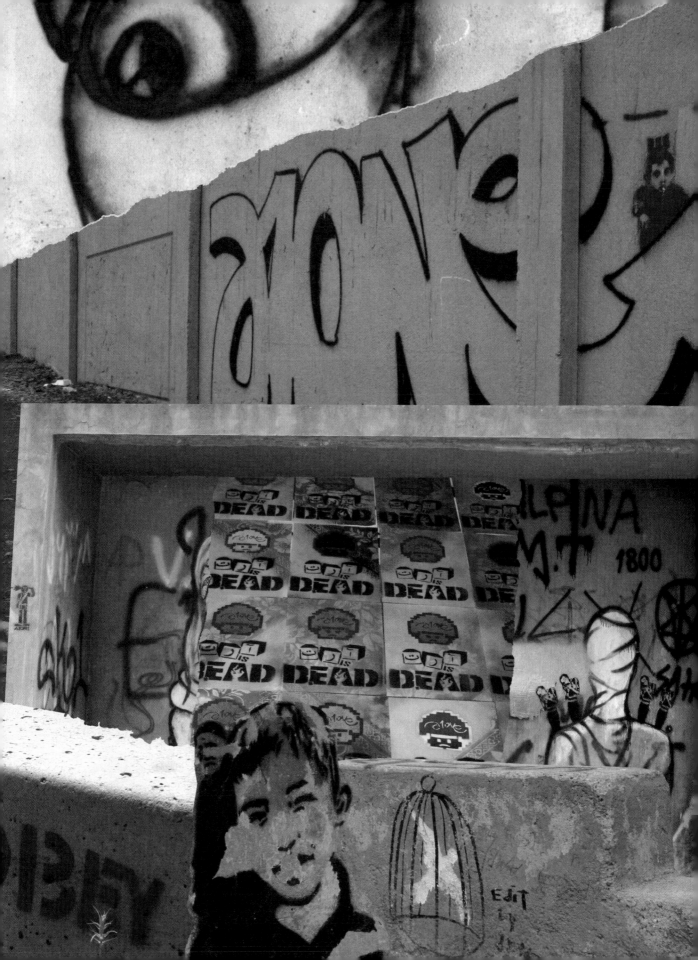

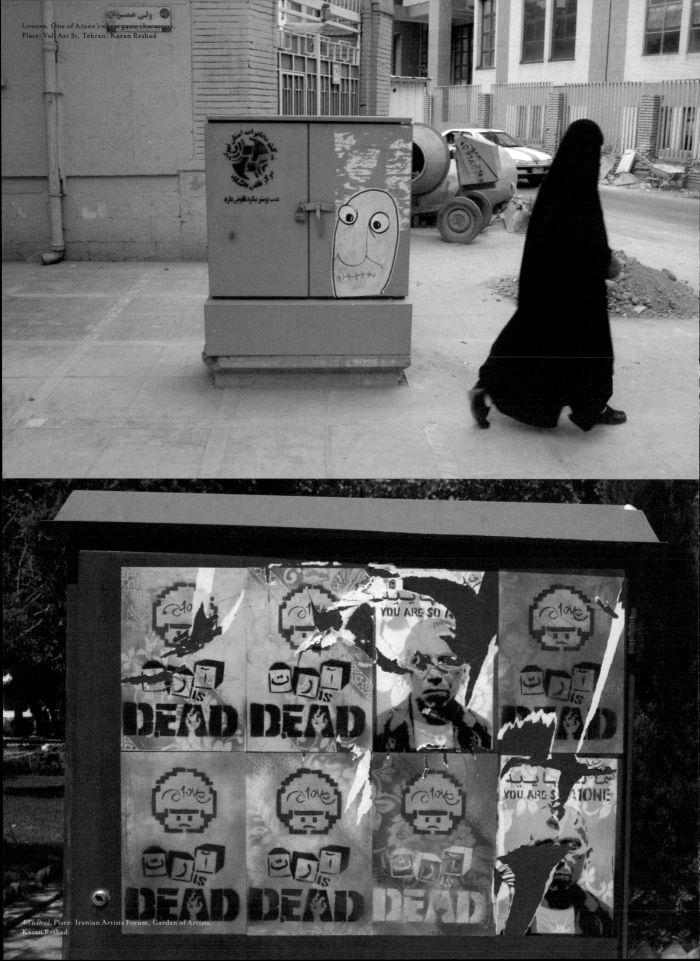

Lonesome. One of A1one's wheat paste characters.
Place: Vali Asr St, Tehran. Karan Reshad

A1 is Dead. Place: Iranian Artists Forum, Garden of Artists.
Karan Reshad

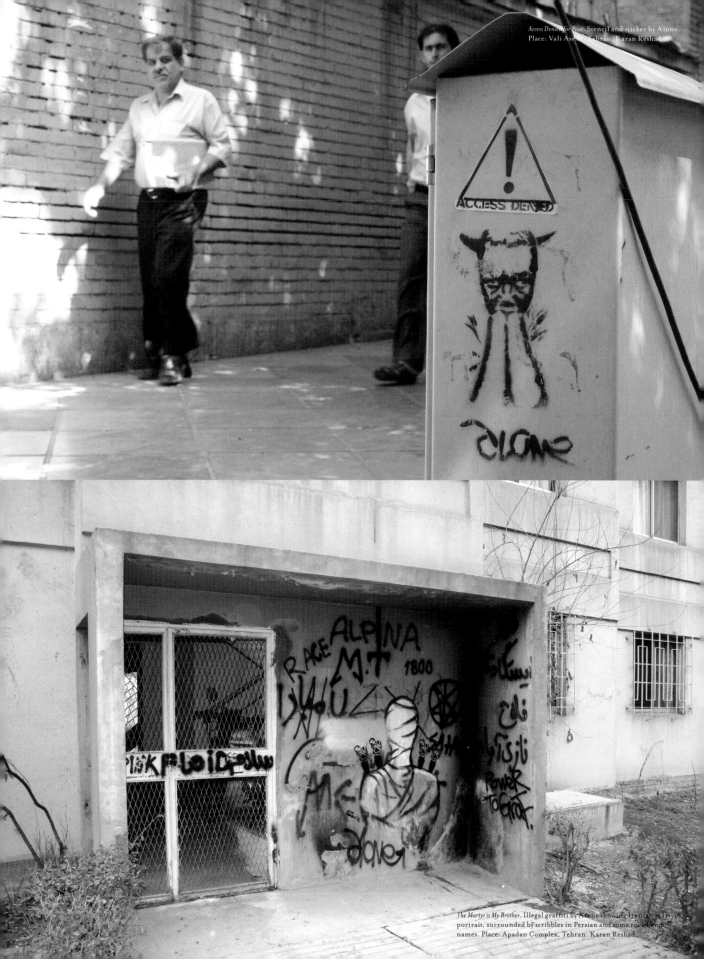

Access Denied for Poor. Stencil and sticker by Atone.
Place: Vali Asr St., Tehran. Karan Reshad.

The Martyr is My Brother. Illegal graffiti by Atone showing Iranian martyr
portrait, surrounded by scribbles in Persian and some rock band
names. Place: Apadan Complex, Tehran. Karan Reshad.

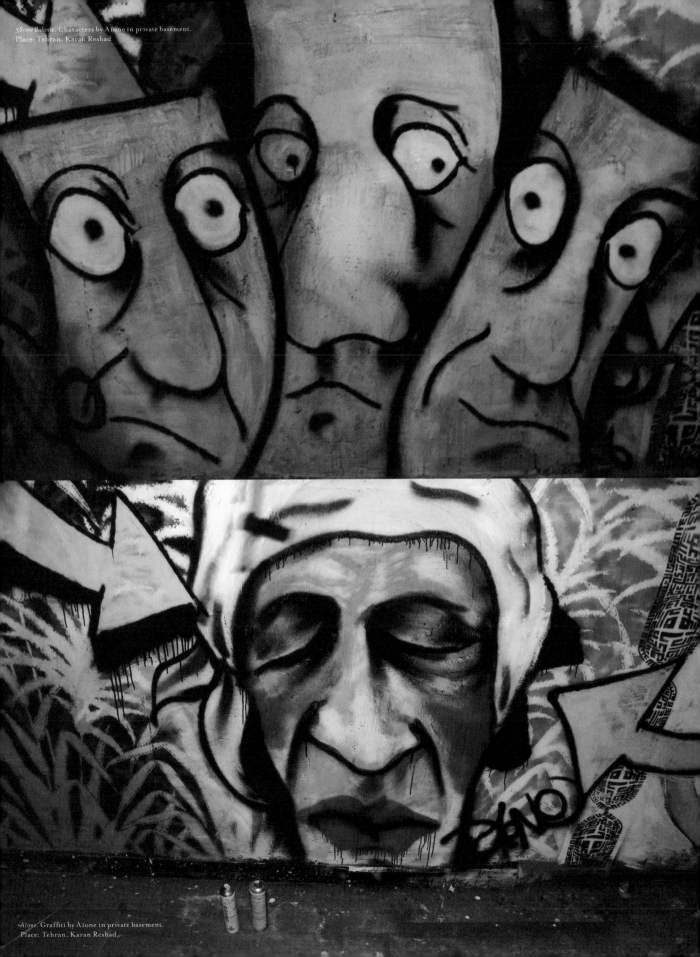

3Some Balance. Characters by A1one in private basement.
Place: Tehran. Karan Reshad

A1one. Graffiti by A1one in private basement.
Place: Tehran. Karan Reshad

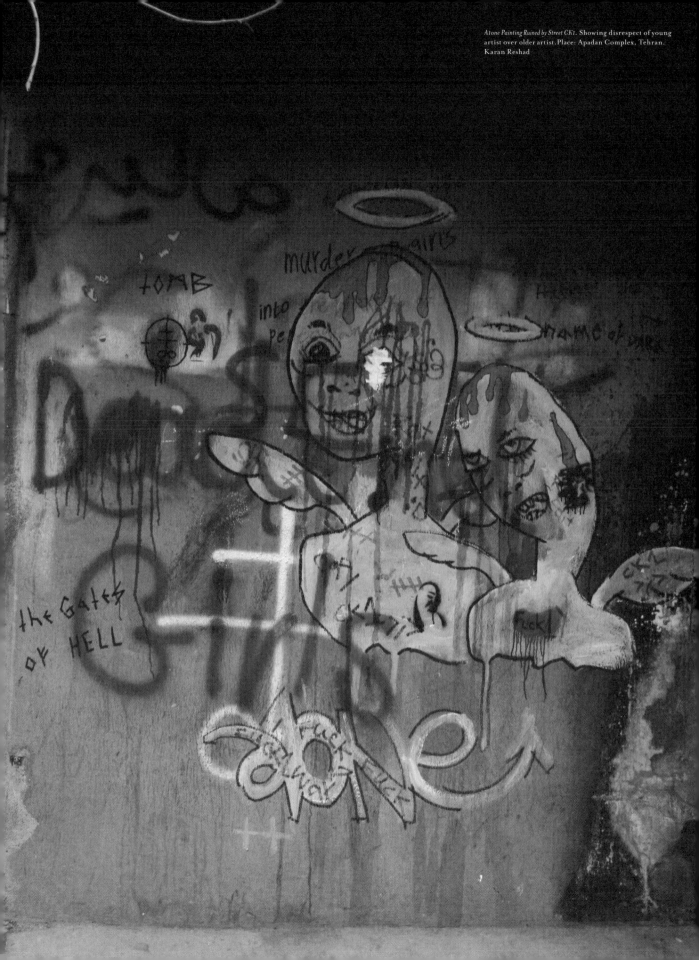

Atone Painting Ruined by Street CK1. Showing disrespect of young artist over older artist. Place: Apadan Complex, Tehran. Karan Reshad

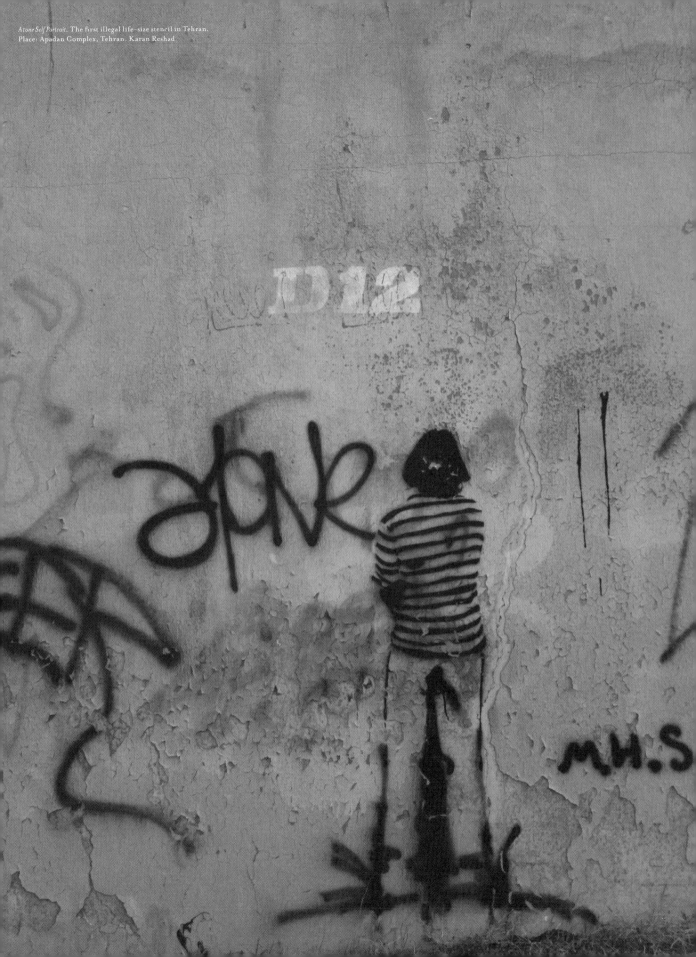

Atone Self Portrait. The first illegal life-size stencil in Tehran.
Place: Apadan Complex, Tehran. Karan Reshad

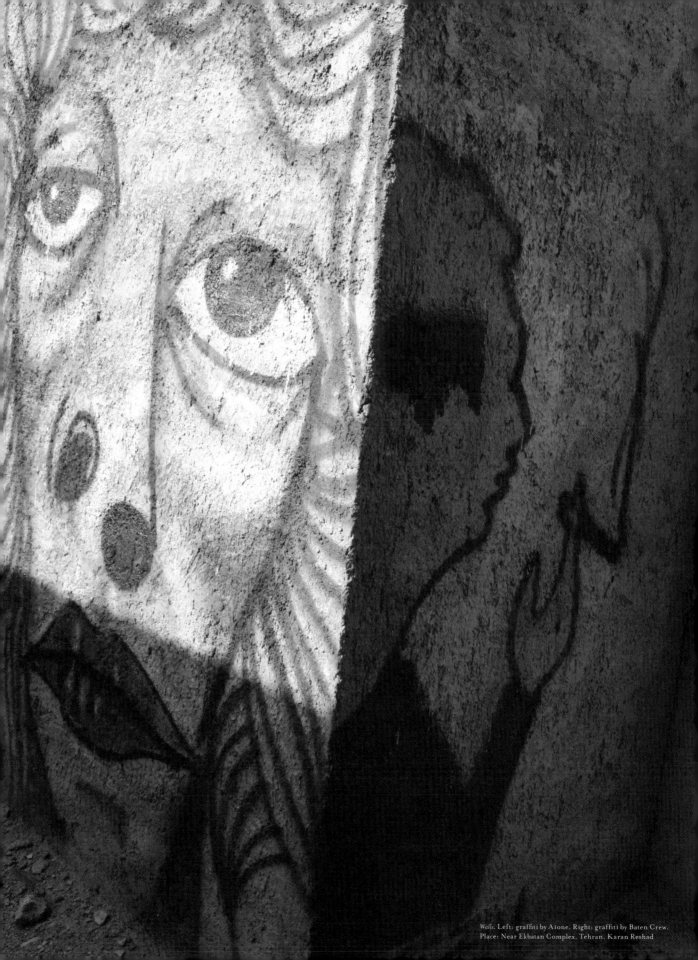

Walls. Left: graffiti by A1one. Right: graffiti by Baten Crew.
Place: Near Ekbatan Complex, Tehran. Karan Reshad

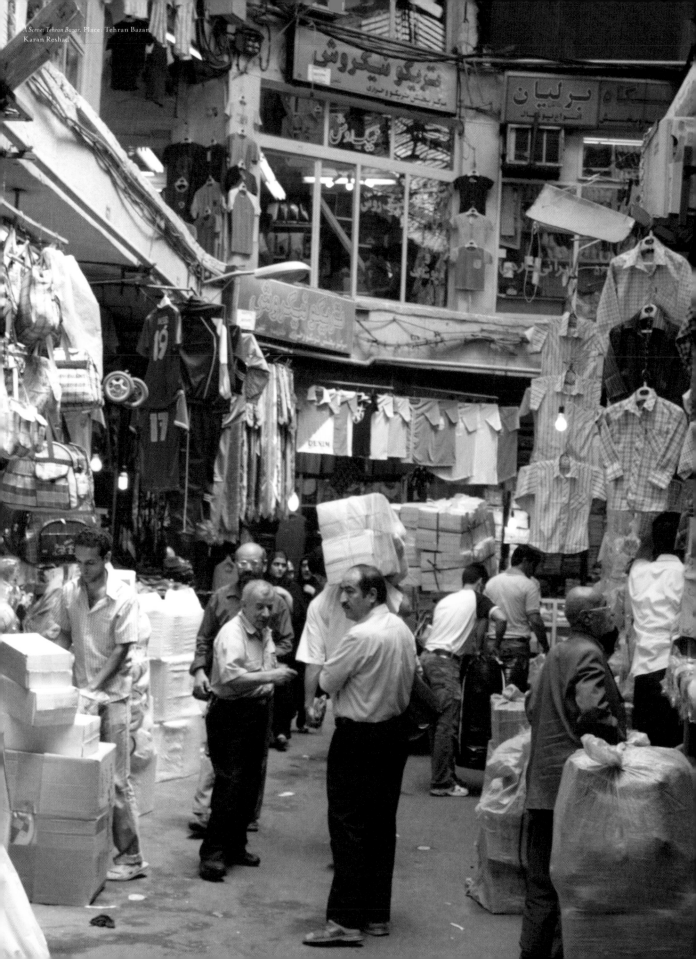

PORTRAITS OF THE EVERYDAY

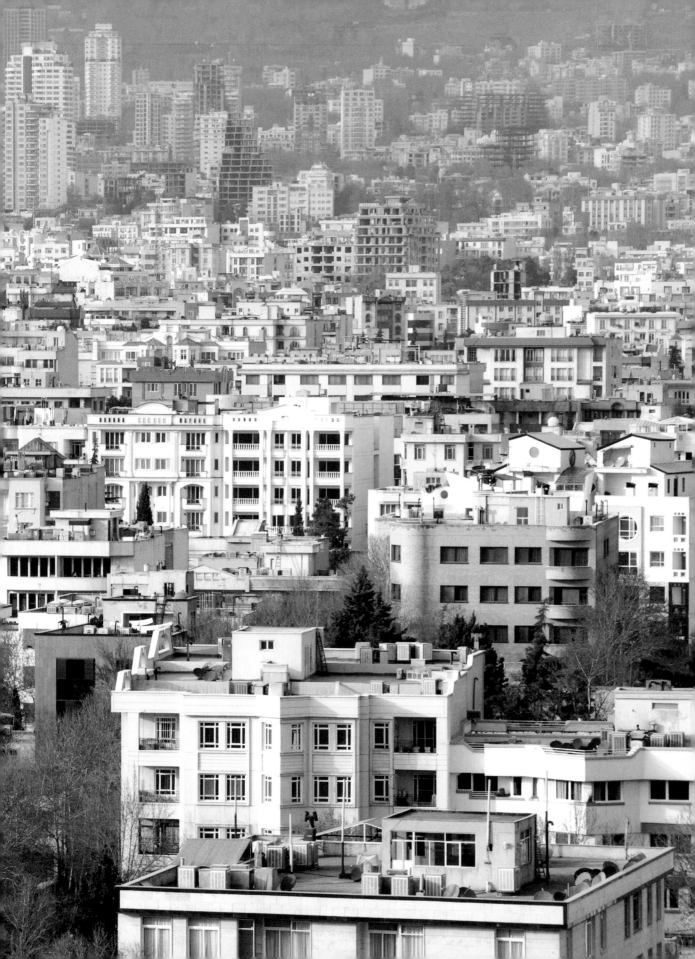

Slab City

BRIAN ACKLEY

LIFE IN TEHRAN'S LARGEST HOUSING DEVELOPMENT

Built during the late 1970s as part of the Shah's push toward Western-style moderniza-
tion, Ekbatan is a massive community, one of the largest of its kind in the Middle East,
sprawling through the center of Tehran. The complex of housing, shops, services and park-
like interstitial space cuts an imposing 500-acre swath across the westernmost expanse of
the city center. It comprises a group of buildings that take the same basic template and
stack them into towering and stepped configurations, with relentlessly repeated ribbons of
concrete and glass wrapping each building in the 15,500 unit super-complex. Ekbatan was
intended to bring a new standard of living, but was never celebrated; right before the
buildings were completed, the Islamic revolution started and brought with it a prescribed
nostalgia for the near-rootless "traditions" of "true Islam" and a related opposition to
forced modernization imposed from above. And as time passed Ekbatan took on the look —
as many extra-large scale modernist housing projects have — of a dystopic prop, a stage for
the critique of the contemporary world more than an ideal for living through it.

Yet, the conditioned allergy to the totality, anonymity and crushing scale of modernist
planning belies an envy of its sweeping vision. Already disillusioned by the inadequacies
and failures of postmodern architecture, we harbor an almost illicit satisfaction for the
successes of its predecessors. In his essay from 1976 on the Bijimermeer housing project in
Amsterdam (a complex that he calls a "socialist Las Vegas"), Rem Koolhaas characterized
this phenomenon as "the father threatening the son" in the perpetual Oedipal cycle of
architectural discourse.

Still, Ekbatan is often perceived as a perversion of urbanism, a ghettoized scar marked by an
isolation that breeds crime and delinquency, although it seems immune to standard attacks
leveled at other housing projects. What one finds within is a largely functioning community
that appreciates its lifestyle, one not riddled with the social and economic strife associated
with the human warehouses of Paris or Chicago. Ekbatan may be traumatic architecturally,
but its test-tube urbanism proves to be functional within the context of Tehran. This is a
result of its positioning in the city, the completeness of the community and its differ-
ence from the other housing projects that are being hastily built to accommodate Tehran's

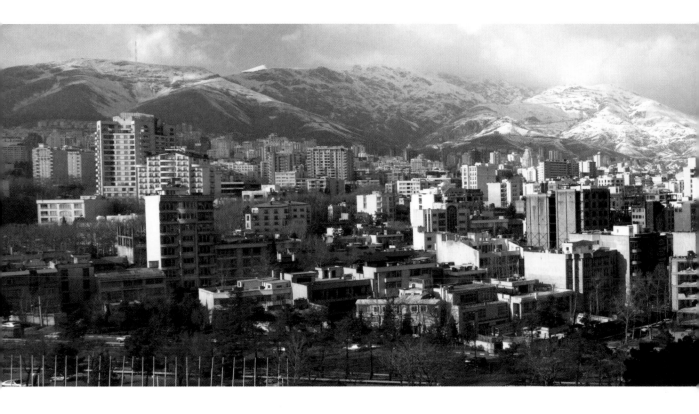

"THE DIVIDE BETWEEN NORTH AND SOUTH TEHRAN IS SIGNIFICANT... NOT SURPRISINGLY, THERE ARE RESENTMENTS AND TENSIONS BETWEEN THESE REGIONS."

population explosion. The divide between north and south Tehran is significant. The north was the focus of the Shah's attempt at cosmopolification, with tree-lined sprawling boulevards and one eye to the West, while the south is a working class neighborhood characterized by dense and polluted streets. Not surprisingly, there are resentments and tensions between these

regions. Ekbatan was placed precisely on the very axis that divides them and is therefore not part of either. In addition to the mediation resulting from this symbolic suspension, Ekbatan collects within its vast complex housing over 70,000 people, a range of people with different cultural beliefs and lifestyles, and throws them all together. The towers are certainly striated; housing all the different strata of the Tehran middle class from civil servants to academics to artists to entrepreneurs, some groups living here, others concentrated there. Yet Ekbatan itself becomes the unifying factor, even among different ideological camps, defusing prejudice or at least fostering a space where prejudices are less likely to be expressed. Unless, of course, you are not actually from Ekbatan —as a teenage outsider, you could find

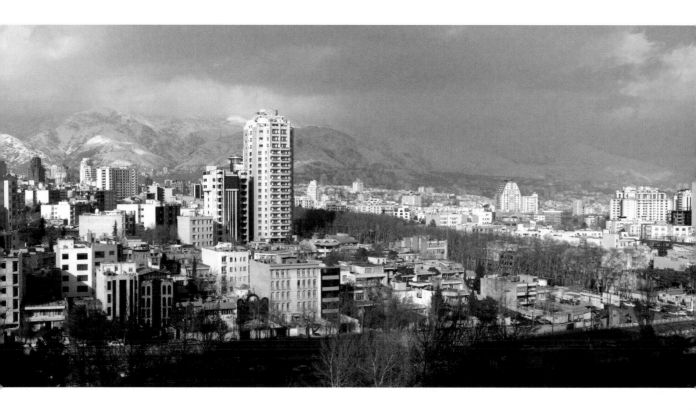

yourself in a spot of trouble. And even as an adult, you'll be confronted with defensive, knee-jerk reactions defending Ekbatan to the end.

This sense of community is reinforced by the fact that, to a certain degree, Ekbatan is its own self-sufficient neighborhood providing the same conveniences that are offered by the city. Parks, malls, gyms, doctors, schools, friends, family — everything can be found right there. For many, there is not much need or desire to step out into Tehran proper. Some people even suggest that the city is a burden on Ekbatan, one young woman going so far as to say that everyone would be better off if the project were in the middle of a beautiful jungle—a far cry

from the attitudes toward disastrous housing projects that were and are being constructed at smaller scales but with lower standards and in undesirable neighborhoods.

Of course there are drawbacks of mega-scale modernism, a practice that eradicates difference and culturally-specific accommodations. There are no longer small courtyards for families to gather for tea, and one sees modernist comedies such as coming home to the wrong building because they all look the same and witnessing your neighbors' most private moments through the floor to ceiling windows. But communities adapt, traditions survive, choices expand and perhaps in the end size really doesn't matter. It's the way you use it. ◉

Originally published in Bidoun, *Issue 06, Vol. 01.*

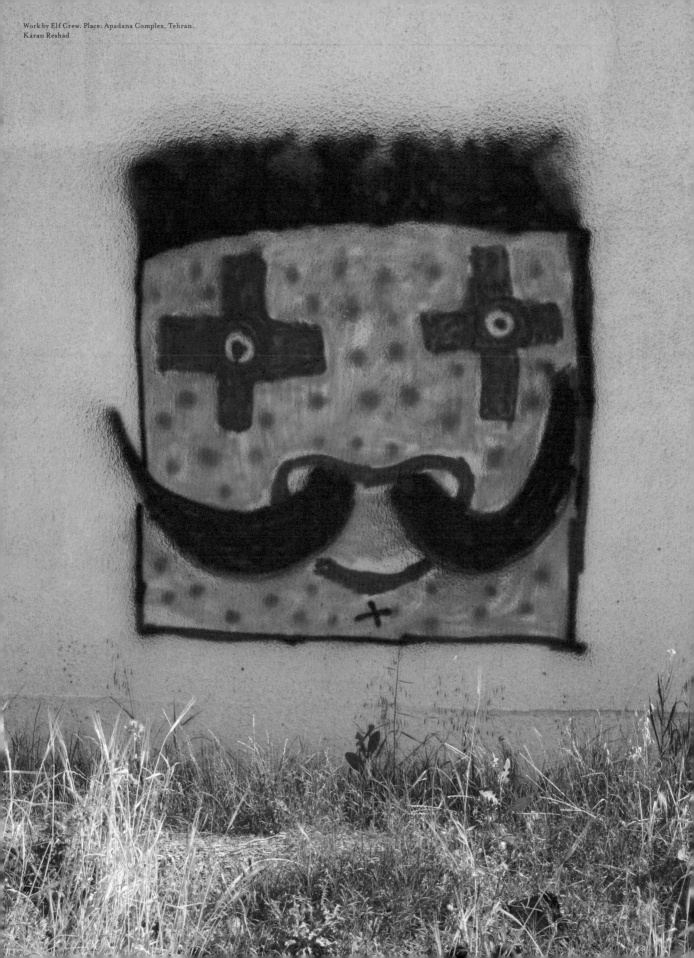

Roots of Rebellion

COCO FERGUSON

BEARDS AND BEYOND IN IRAN

It seems that "unconventional" hairstyles are this season's taboo in the Islamic Republic. "Football clubs have been ordered to stop players with long, messy hair, ponytails, hair bands and certain kinds of beard, or they will be fined and banned from playing," warned Iran's Football Federation in November.

"Unconventional" beards reference a host of Iranian variations on the goatie (*bozi*). The *professori*, the thicker traditional version and the *diplomat*, a sculpted matrix of thin lines from lip to chin, are both under fire: last year the Tehran passport office stopped accepting either, demanding either a full beard or no beard at all in official pictures. Photo studios opposite the office digitally erase offending beardlets on request, producing computer images, which the authorities then accept. Less inventive travelers head, glassy eyed, for the barber downstairs. Goaties have also become the *bête noire* in official advertising. A new cartoon advert on Tehran's highways warns of the dangers of driving and mobile phones. It sketches a fast-living young gun wearing the shades and studied *diplomat* of North Tehran coffee-shop cruisers: he shouts into his mobile as he ploughs into an angelic, veiled, young girl.

But despite being unorthodox, renegade beardlets now outnumber the beard on Tehran's streets and new regulations are unlikely to have much affect. Recent restrictions are testimony to a conservative attempt to shore up revolutionary self-presentation, long on the defensive. In 1979, the full beard became the flag-bearing reversal of the smooth-cheeked *pahlavi* model and Ayatollah Khomeini himself underlined Islamic *fiqh* against shaving. But after less than a decade of pre-eminence, the beard's crown began to slip, and creative razor work has been undermining its position ever since.

The Pahlavi era was marked by a clean-cut reorientation Westward, sandwiched between two eras of hairier clerical influence. Reza Shah banned chadors in 1936 and endorsed shaving in his drive to "modernize" Iran, dragging his country toward Europe and brow-beating it into gender desegregation. Until then, smooth cheeks had been a passing stage, the ephemeral beauty of the *ghilman*, heaven's lithe cupbearer, on the road to clerically

mandated, bearded adulthood. Amongst the elite, the tide had been flowing toward the European pretty-boy since the turn of the century, but with Reza Shah's injunction the Iranian male lost a potent emblem of manhood, and the moustache drooped under the pressure to fulfill the beard's former role.

Though today a dying breed among Iran's youth, for the older generation, and in northwest Iran, moustaches have maintained their past significance. "By the hair of my moustache" remains a binding pledge for Kurds and Lors. A Qomi Ayatollah was handed a hair from a Kurd's moustache, carefully plucked and filed in a plastic wallet, as surety for a loan of 50,000 tuman ($44). A year later the Kurd returned with the money, to the Ayatollah's surprise and pleasure. His smile faded, however, when the Kurd adamantly demanded the return of his hair. A panicked rummage through drawers and cupboards finally yielded the item, and the Kurd departed, his honor satisfied.

The Islamic revolution tipped the balance back in favor of the beard. A bushy beard bore the double hallmarks of Islam and the Red Revolutionary. Fidel Castro, whose own beard has for so long been the object of tragic-comic CIA machinations — exploding cigars and depilatory dust attacks top the list of intrigues — became a favorite of the new establishment. But aside from its philosophical symbolism, beards soon signaled adherence to the new regime, and became an employment and university prerequisite. Iranian Communists maintained their uniform of short hair, thick moustaches and spectacles for the first few years of the revolution. But by 1981 their tokens were fading, sinking into the sea of conformist beards as they came under attack.

Wall paintings are odes to the beard's glory days. Memorials to martyrs throughout Iranian cities almost exclusively feature men with beards or at least a heavy *tah-rish*, the revolutionary stubble that is still favored by soldiers and intelligence agents, most often meticulously painted a moldy green in murals. The unbearded portrait signals youth, full growth denied by death. The beardless martyr sacrifices his manhood for the revolution, and the celestial lights, fields of flowers, beckoning sunsets, invoke once again the *ghilman*.

But from the end of the Iran-Iraq War in 1988, beards of ordinary Iranians started thinning. In 1997, President Mohammad Khatami's suave beard and pressed clothes accompanied an easing of social regulations and altered "the rougher the better" principle that had lived on in establishment corridors. It was the beginning of the end. Clerics trimmed their manes, and stubble started fading from government ministries. For the first time, long-haired boys found themselves un-harassed in universities. Today, dreadlocks remain a pipe dream but on the streets of the capital, shaved patterns of the hip-hop generation are taking their tentative first steps.

Ahmad, proprietor of Mootah, "Tehran's best barber," pioneers these new styles. His salon is tucked away upstairs from a quiet mall near Shariati, a major Tehran boulevard. High-maintenance males bask in the warmth of hair dryers, admire their highlights and pat down implants on leather-padded swivel chairs. Foreign styles have long influenced Iranian barber techniques, and satellite-beamed international football is today's strongest influence. Ahmad charted the history of "the West" on Iranian hair for me one day, from Elvis and the Beatles to "the Beckham" and the

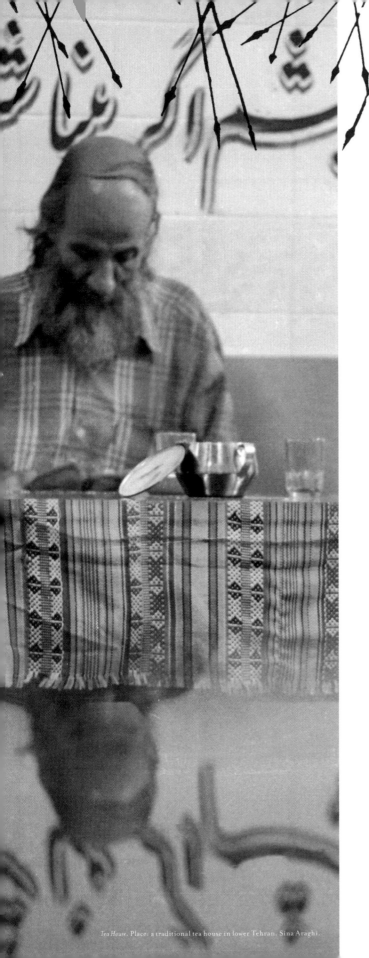

Tea House. Place: a traditional tea house in lower Tehran. Sina Araghi.

"del Piero." My name, Cornelie, it turns out, is the Iranian version of John Travolta's *Grease* bonce, a dinosaur still lurking in "the provinces." While the Duran Duran *posht boland* (mullet) lingers on it's the plain, shaved staple of Western offices that's gaining ground.

And today, as the razor calls siren-like even to news readers and policemen, the beard is scrabbling for a role within the official message of the establishment. While a bearded renaissance has been gaining ground on the margins for the past few years among artists, poets and musicians, the style is an emblematic world away from its revolutionary counterpart. Their long beards, long hair and long moustaches have a separate history, rooted in both the Sufi Dervish and the hippy, in an ironic to-and-fro of East and West. In a twist of fate, this style was in fashion in the late 7th and 8th centuries: it announced opposition to laws laid down by Arab invaders bringing Islam and shaved upper lips to the land of the Aryans. The revolutionary beard, once the sign of conformity, is confronted by a rival contender.

But as the once-ubiquitous revolutionary model becomes sidelined, styles that formerly signaled opposition are becoming just another form of self-expression. In the relative freedom of modern Iran, men have abandoned the fanfare of the great historical *volte-face*, and are sounding the death knell for the facial icons of Iran's recent past. The disappearance of these traditional symbols of manhood flags the demise of the Iranian uber-male in favor of the cherub-cheeked international everyman. ⊙

Originally published in Bidoun, Issue 03, Vol. 01.

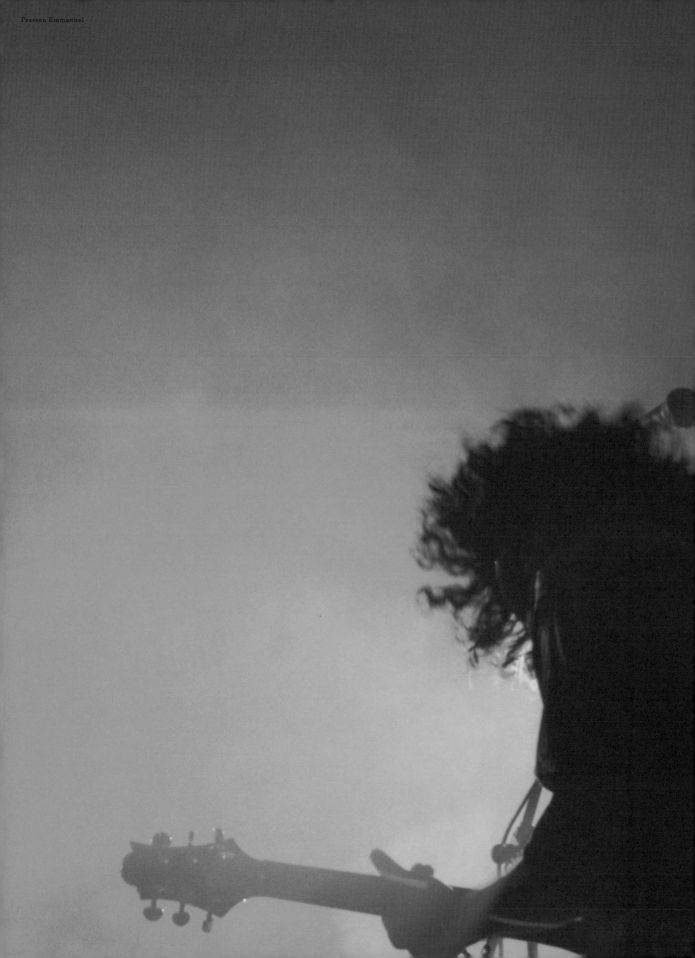

Hair is for Head-Banging

COCO FERGUSON AND SOHRAB MOHEBBI

A GLANCE AT IRAN'S METAL SCENE

We leave his mother half-watching Russian TV in a crocheted cardigan and head into the next room. Kahtmayan's drummer puts on Dream Theater's latest CD as we inspect the satanic iconography on the walls. He spins tales of oblivion at Dream Theater's last Istanbul concert and offers us more tea. A strangely easy coexistence of the macabre and the mundane met us at every juncture as we peered into the Islamic Republic's metal scene.

Kahtmayan have a concert in one month in Semnan, a city south-east of Tehran. Esfahan and Mashad have hosted the only metal concerts to date outside the capital and even within the mega-metropolis of Tehran they are a rare phenomenon. "We're the first metal band they've seen," explains Ardavan, the group's bassist. "It's going to be sick." Kahtmayan have been playing together for two years and are one of Iran's best known outfits. The concept of metal is alien to Iranians of an older generation but it has a huge following of youth who manage to paralyze home phone lines for days downloading tracks. A book of Metallica lyrics is on its eighth print run and hundreds of bands are registered on Tehran Avenue's (one of Iran's most active cultural websites) Underground Music Competition (UMC). Recording in bedrooms and broom closets, bands from all over the country enter songs and online voters pick the winners. A gothic metal track by the young group Amertad won last year's second prize.

Kahtmayan's sound is heading slowly away from thrash toward progressive, almost funk metal. In their new track, "Irreversible," keyboards break into an incessant baroque horror of the fairground, before giving way to the increasingly intricate insistence of the lead guitar, underlined by a fast funky bass. But their fans aren't happy with their new direction. "At our concert last year bodyguards had to pull back kids shouting for harder, faster songs," complains Homayoon, the group's guitarist and driving force, as he ties back the mane of hair he let loose for the session. Homayoon, who heard Iron Maiden for the first time aged 12, has been working on a solo album, deftly piecing together Arab and Marakeshi rhythms with old Iranian melodies, layered on the foundations of Western metal. "Sony liked it but I can't release it. There's no market here for experimental metal," he says with a dry smile.

Kahtmayan are not alone in seeking new waters. Pod, a band who made their name playing Dream Theater covers, have started weaving their own fierce but complex sound, labelling themselves "progressive" without hesitation. Every Sunday they gather in a Fifties bungalow in a gated leafy enclave near Karaj, Tehran's industrial annex, where an elderly gentleman in silk paisley pajamas welcomes us. They believe there is a market for their music: "Joe Satriani (a US progressive metal legend) plays to 500 people in the States. If he came here, he could fill the National Stadium." I balance my teacup on the Marshall amp and ask if that's because Iranian kids understand his music better. "I guess they're just hungry for anything," Arash Mogaddam, the band's drummer, says rethinking.

Both Kahtmayan and Pod have encyclopaedic knowledge of Western metal, rock, pop and Iranian classical and modern music, which fold into their subtle constructions without artifice. The results are inspiring. Pod has also had two concerts in Tehran, but the process nearly broke them. "Running up and down *Ershad* steps (the Ministry of Culture and Islamic Guidance) was exhausting," explains Ardavan, their lead guitarist. "The permission only came through days before the concert. Every Iranian band has had more cancellations than concerts. They wait until the last minute. And they never say no. They just trail you along until you get cold and give up."

Mogaddam, a prodigiously talented drummer who lived in the States for years, pictures Iranian metal in a painful never-land. "When this was all totally underground, totally unac-

ceptable, we found our own way outside the system. Now bands are bending themselves, morphing to play by the rules and losing themselves in the process." Amertad, now firmly on Iran's metal map since their success at Tehran Avenue's UMC, produce two versions for every song: the *Ershad* version and the music they want to play. Their website has attracted a fanbase from Norway to Japan, but they've never performed live. Their mix of gothic metal and Iranian traditional sounds, translated from the *setar* and the *santur* onto the violin, reverberates no further than the egg cartons lining the walls of their bedroom/practice room. Fans have to make do with blurry pictures of the drummer, stripped to the waist, nestled between teddy bears and computers. Since this summer's elections returned radical conservatives to government, metal music has taken a battering: Iranian state television recently declared Metallica "against Islam." Jazz and classical concerts are now routinely cancelled and it will be a while before any of these groups get back on stage.

Sipping tea in leather loafers in the smooth white space of his recording studio, Farshid Arabi is the success story of Iranian heavy metal. Last year he released the only officially sanctioned metal CD in Iran, an unlikely combination of Mowlana (a canonical Iranian poet) and the soaring guitars of old-school heavy metal. He spent three years trailing after permits and finally gave up. He turned to the music mafia, four or five producers with a stranglehold on the business who print CDs, conjure up permission and bankroll concerts. They produced his CD for free in return for the profits. Their world is the soft pop bubblegum of Tehran traffic jams, but they

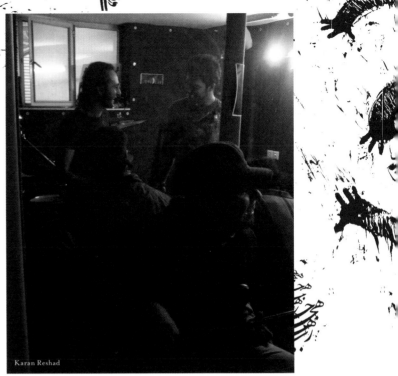

Karan Reshad

were prepared to take a chance, and sales have been good. For him the underground is definitely over. "Fifteen years ago, when we started, if they found you with a guitar, they'd smash it over your head. Now everything's on offer." The last eight years of eased social regulations under President Mohammad Khatami have brought electric guitars, mixing desks, amps and drum kits to Iran's musicians. But though they now have the means, the cold war is on for a platform.

Bands remain that can't and won't work with the system, that still rage into a sweaty mic at the world around them. Squeezing past a Mercedes Benz in a North Tehran garage, we head downstairs, following drumbeats. Crammed into a sauna, guitar cases resting on the jacuzzi cover, are Scourge, angry "motherf****ers," who despite only five months together, pump out convincing Judas Priest, Carcass and Megadeath covers, interwoven with their own "brutal" songs. Their growling screams spread fury and destruction and their hair is magnificent: two guitarists have thick locks to the waist, which soar and crash as they hammer out thunder. The bassist looks like a *Safavid* monarch and though his hair is shorter, he leans sideways and thrashes till sweat drips from the roots. "Death Metal is the only music I listen to," explains Reza, the vocalist. "It's the only music that speaks to my soul." His studded leather wristbands are only slightly undermined by the stick-on tattoo on his bicep. Arvin, who brought us here, compares the session with a brief history of Napalm Death (a Birmingham band). Blood drips from skulls on his Death t-shirt, but he looks surprisingly clean-cut. "I've had to shape up for 8 months of military service,"

he explains. But he can't help himself and plays air guitar with the conviction of a true metal-head.

But apart from the friends who shuffle for sauna space on Friday afternoons, no one has, or will, hear the Scourge sound. They have carved out a private world where they are free to play and do what they want. And to date Scourge have styled themselves into carbon copies of the Children of Bodom and Megadeath posters on the walls, from the hair cuts to the chord changes.

Others who are willing to negotiate the system have been forced to adapt and reinvent. And while they feel and resent the squeeze, bands like Pod and Kahtmayan are creating truly original and arresting tracks. For these bands metal can't be "a way of life." It's just about the music. Image has yielded place to intense, intricate and original sounds in a third space beyond metal's Western roots or its Iranian home. Kahtmayan's album *Virtual Existence* is a hymn to the isolated but dynamic world sustained by global computer networks that are Iran's music scene. ◉

59

Originally published in Bidoun, *Issue 03, Vol. 01.*

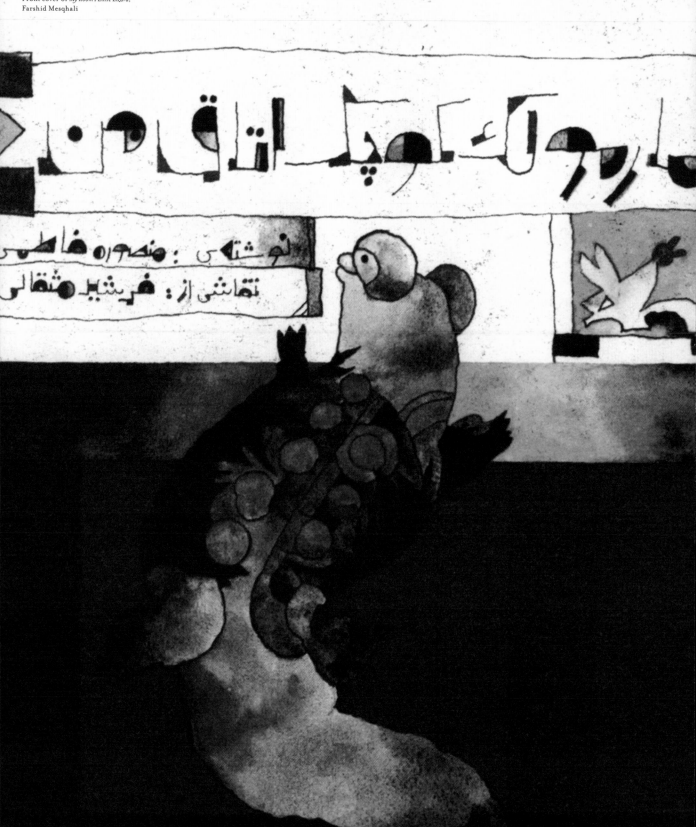

THE ART OF PUBLISHING

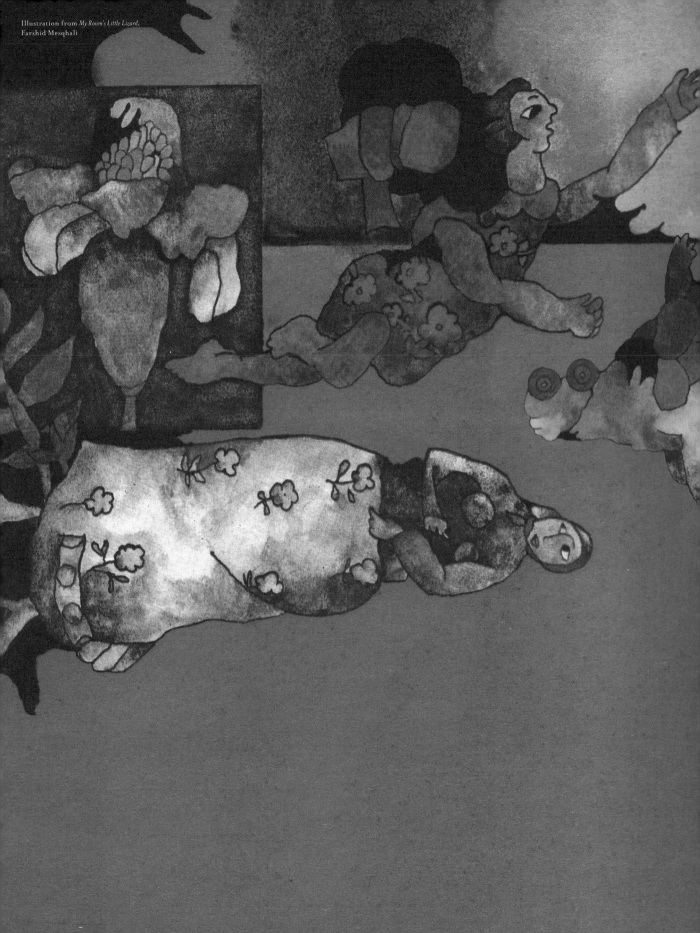

Introduction

CHARLOTTE NORUZI

"Who I am" became a distant dream when we moved to America in 1977. My childhood, filled with the security of my little friends, family and my big room full of dolls and Legos was gone. But in my mind's eye, that room remains vivid. I could tell you where everything was: on the bed, walls, shelves. Yes, on those shelves were books. Books, it seems, have always been in my life. They have at different times provided knowledge, inspiration, solace. Both of my parents encouraged reading from a young age and I remember reading with my mother every night to strengthen my English, whether or not she understood all that I was saying.

Having lived in America most of my life, absorbing its culture and shunning my own for the most part left little room for Iran. This essay woke something up in me that had been dormant for years. Before writing it, the possibility of re-visiting Iran was a dim improbability for me. Calling Iran never crossed my mind. During the process of contacting artists, writers, graphic designers and publishers, I have opened many doors and allowed myself to peer into the culture I once inhabited. I am grateful to the people I have connected with in Iran who have "opened their doors" to me, being so giving of their time, thoughts and work and so willing to assist me. Their curiosity and enthusiasm matched and sometimes surpassed mine. The deeper reason of writing this, I realize now, has been to re-connect to who I am.

When my family first moved to the United States, my father was still traveling back and forth to Iran before joining us permanently. After one trip, he brought with him a small collection of Iranian children's books. These books, along with numerous others, were created under the *Kanoon Parvaresh Fekri Koodakan va Nojavanan* (Institute for the Intellectual Development of Children and Adolescents). To me, its iconic stylized rooster logo conveyed a positive and bright outlook for the betterment of children. In 1961, the Kanoon was established to enhance the quality and educational standards of children's literature and activities. A large part of the program was devoted to the publishing of high-quality, richly written and illustrated books for children and adolescents.

I have six books from that era. They were loaded with cultural and historical references and set apart from each other and from my American children's books in their individual and unique styles of illustration.

(Continued on page 66)

Illustration from unknown Pahlavan Pahlavanan
children's book, Ali Akbar

In times where I felt the most disconnected, the most doubtful of my identity, I would turn to these books, get lost in them, in the fantasy of them. They were my one connection to the culture I left behind. In them I found some remnant of my past life. I would open a book and feel like I was "home" again. I see now how the seeds to express my thoughts and ideas through pictures were sown. Out of the endearing times I spent with my little collection sprung the desire to illustrate books, to use calligraphy and hand-written text. This was my introduction to art and words living together and there's a little from each book in some aspect of my work, my own children's book.

My favorite of the collection is called *Marmoolak Koochak Otagheh Man* (My Room's Little Lizard) by Farshid Mesqali. Its Chagall-like, surrealistic watercolors draw you into the realm of dreams. The hand lettering of the book's title and the deep black, blues, greens and purples that bleed softly into one another, making up the body of the lizard, were so beguiling to me. They still are. I see the influence in my own work. *Baba Barfi* was another, done in gorgeous hues of blue and greys, in a mix of drawing and watercolor. There is a quiet simplicity in the illustrations and the story that reminds me of the silence right after snowfall.

"THEY WERE MY ONE CONNECTION TO THE CULTURE I LEFT BEHIND. IN THEM I FOUND SOME REMNANT OF MY PAST LIFE. I WOULD OPEN A BOOK AND FEEL LIKE I WAS 'HOME' AGAIN."

Illustration from *Baba Barfi (Father Snow)*, Ali Biyashi

Another book that inspired me to want to "illustrate words" was my Farsi book, an educational book for children going into the second grade, the grade I was going into at the time of our move. In it were short stories (all of which ended with moral lessons), question-and-answer and writing exercises, along with poems and educational/scientific pieces on, for example, the advent of fire or a caterpillar's journey. Although the illustrations did not have the same richness and draftsmanship of the other children's books, they still resonated with me in their simplicity, their flat and colorful collage-like shapes. One of my favorite stories is about the stubborn rooster Ghoo Ghoo Lee Ghoo Ghoo and his determination to stay outside the coop all night, while all of the other animals retired to their warm beds inside the barn. Subsequently, a heavy rain falls and a regretful, drenched and humbled rooster emerges in the morning, having learned his lesson: "listen to your elders" — a common theme of the stories I grew up with.

(Continued on page 71)

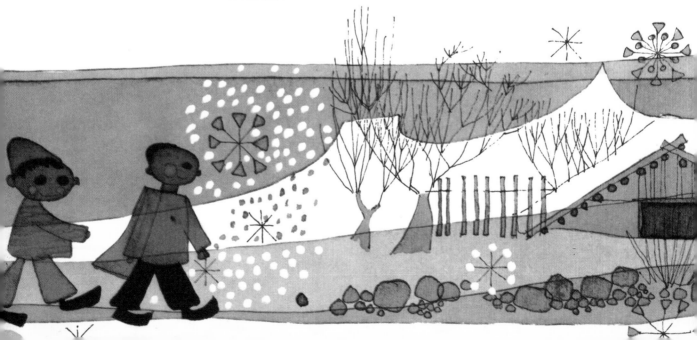

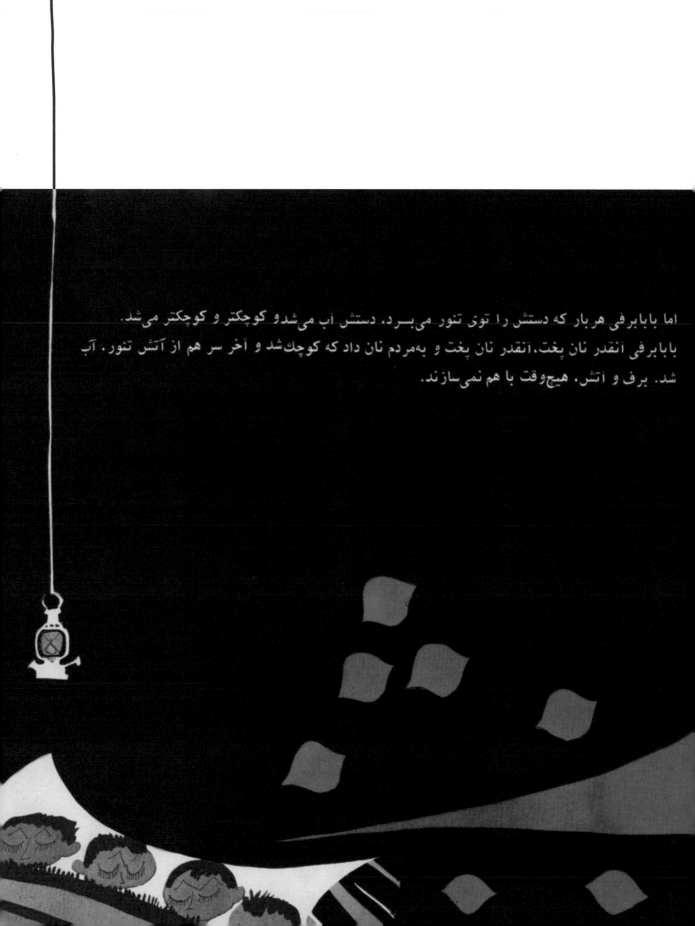

اما بابابرفی هربار که دستش را توی تنور می‌بـرد، دستش آب می‌شدو کوچکتر و کوچکتر می‌شد. بابابرفی آنقدر نان پخت، آنقدر نان پخت و به‌مردم نان داد که کوچک‌شد و آخر سر هم از آتش تنور، آب شد. برف و آتش، هیچ‌وقت با هم نمی‌سازند.

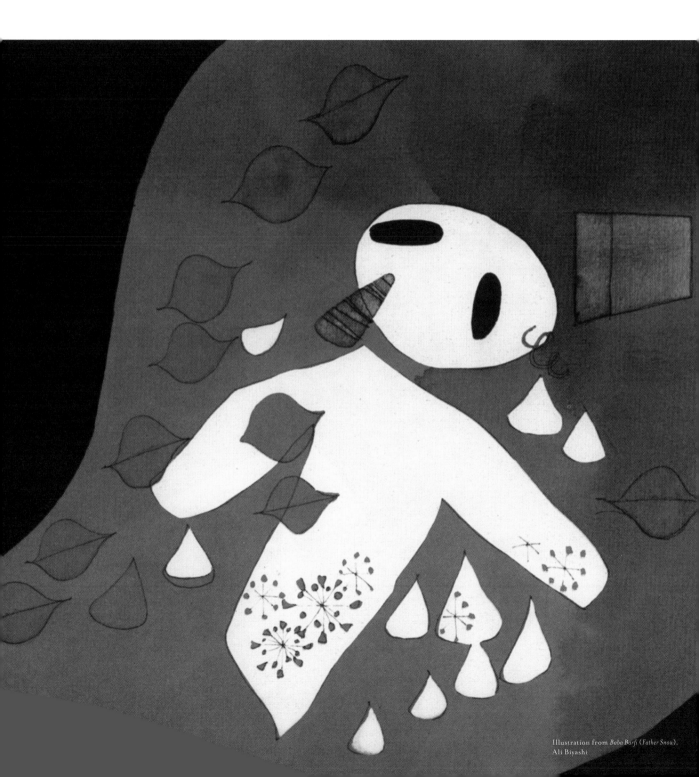

Illustration from *Baba Barfi* (*Father Snow*),
Ali Biyashi

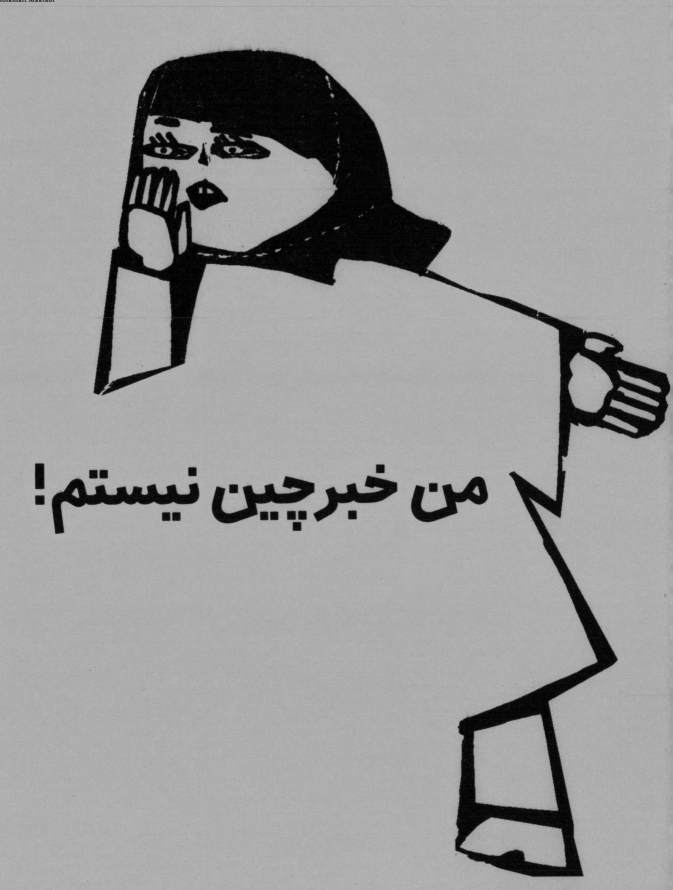

About 12 years ago, my mother visited Iran and brought back with her another set of children's books. These happened to be illustrated by an important figure from my childhood: Gholamali Maktabi, someone I hadn't thought of in years. I never until now got the message of the giving of all these books, first by my father and again by my mother. I had tucked Maktabi's wonderful books away in my memory all of these years and not until the idea for this essay presented itself, did I bring them out into the light. And he came out along with them.

Gholamali Maktabi was my father's dear and life-long friend from their school days. He was a part of our family and we endearingly called him "Dhayee Maktabi," which means Uncle Maktabi in Farsi. I remember a sense of warmth always surrounding that name. I knew him first as the person behind the poignant, sensitive photographs taken of us in Iran as we were growing up. The images he recorded have served time and again as windows into my childhood, my personality as a child, images that connect me with who I was. His innate ability to capture with such simplicity and affection the smile or frown of a child can also be seen in his lifework as an illustrator of children's books. Dhayee Maktabi would spend time drawing with my

sister and me when we were children. Little did I know that those little sessions would awaken a desire for art and expression. I made the important connection between my love of children's books and the time spent with Dhayee Maktabi drawing as a child.

In October 2007, after more than 30 years, I called Dhayee Maktabi. He said I sounded the same and I may as well have still been 4 years old. No time, it felt, had gone by. It was wonderful to hear his voice and talk to him. As a result of my correspondence, I am able to feature here some of my favorite pieces from his vast collection.

"I was drawn from a young age to painting," Maktabi remembers. "This interest ultimately led to my desire to become an illustrator and slowly began to replace painting for me — though to this day I still have a special love for drawing and painting. I've spent about forty years illustrating children's and adolescent's books and I expect that I will continue to do this for the foreseeable future. The thing that has always attracted me to illustrating for children and adolescents is the world that they inhabit, one which is full of mysteries and secrets."

Indeed, I believe that those photographic portraits of my family done long ago also served this purpose. My mother told me recently that Maktabi loved to just sit and observe us, our games and antics, our "secret worlds" that, through the small window of his shutter, were lovingly revealed. ☿

"IN TIMES WHERE I FELT THE MOST DISCONNECTED, THE MOST DOUBTFUL OF MY OWN IDENTITY, I WOULD TURN TO THESE BOOKS."

71

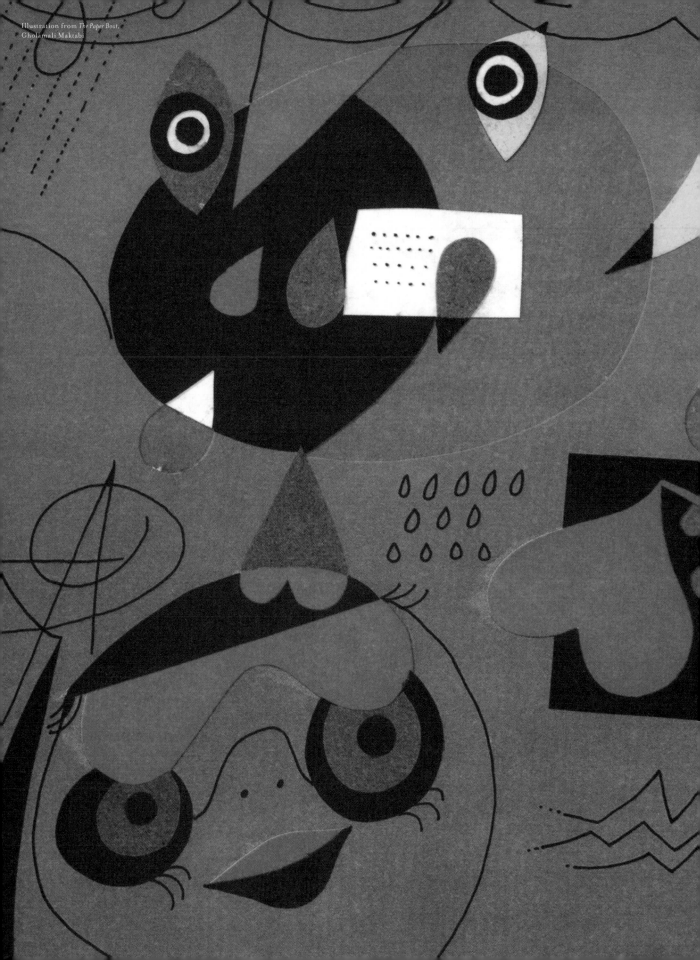

Illustration from *The Paper Boat*.
Gholamali Maktabi

MAKTABI

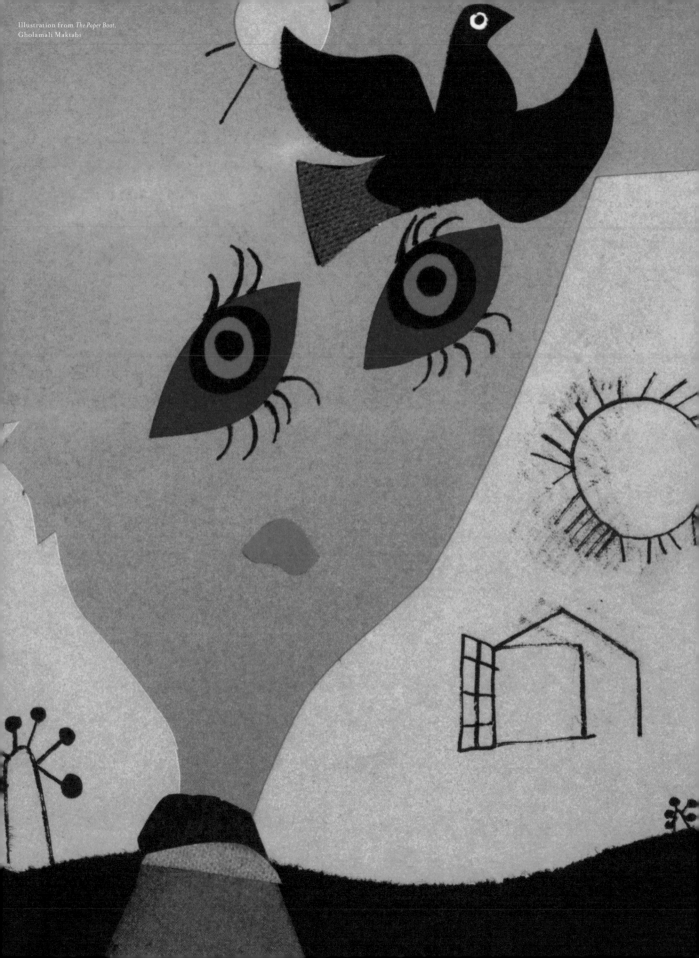

Maktabi

CHARLOTTE NORUZI

Gholamali Maktabi was born in Ahvaz, Iran, in 1934. He attended The College of Arts of The University of Tehran and continued his studies for 6 years at the Beaux Arts Institute in Paris. After returning to Iran, Maktabi pursued his life-long, prolific career. His impressive repertoire encompasses the world of children's book illustration, having illustrated over 50 non-text book children's books, and also, study aids and educational aid magazines such as *Peyk* and *Roshd*. He shared his knowledge with young artists for 11 years at The University of Tehran, University of Al-Zahra, Azad University and College of Seda va Sima from 1985-1996, giving instruction in painting, illustration and color technique for children's books. In recent years, Maktabi has received recognition and awards from several organizations, namely top prize for the Best Book Cover, as well as The Special Prize for Body of Work at the 9th Festival of Books from Kanoon (a still functioning organization). He was awarded Best Illustration for Children's and Adolescent's Book at the 5th Festival of Children's Periodicals, 1996; commendation at the 4th International Festival of Children's Books Illustrators, from the Society of Children's Illustrators and from the Office of Educational Aids Publications, 1999. He was also featured at the Biennial of Illustrations Bratislava, 1998 and 2002.

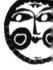
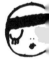

Illustrations from *The Sky is Still Blue*,
Gholamali Maktabi

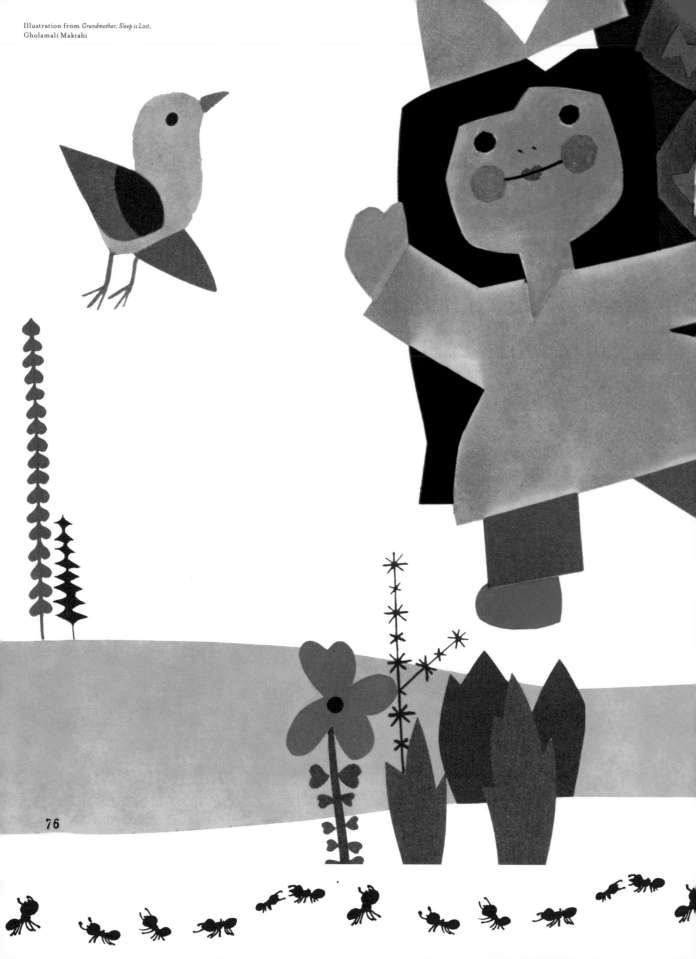

لا و پایین می‌پرید و سی...

یلی عصبانی شده بود، فریاد بلندی کسی...

ٔ : گفتم ساکت باش!

با این فریاد، مادربزرگ از خواب پرید و

سان گفت: ها؟ چی شد؟ کی بود؟

لا و عروسـك، خنـده‌اشـان گرفت.

گفت: هیچی مادربزرگ! ما بودیم. داشتیم

ی می‌کردیم.

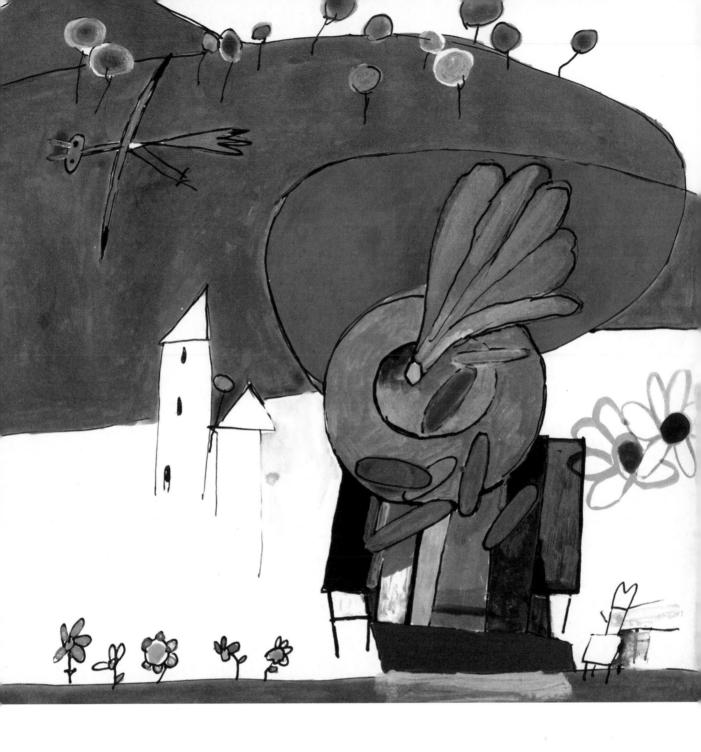

78

سبز

برگِ درخت، سبز است
رنگِ خیار، سبز است
از فصل‌های هر سال
فصلِ بهار، سبز است

جنگل همیشه سبز است
سبز است رنگِ کاهو
سبز است رنگِ سبزه
سبز است چشمِ آهو

80

Illustrations from *Flower, Wind, Rain*,
Gholamali Maktabi

برف

کجایی برف زیبا؟
چرا پس دیر کردی؟
ببین ما بچّه‌ها را
ز خود دلگیر کردی

نگفتی بی تو این فصل
ندارد آب و رنگی
ندیدی کوچه‌ها را
چنین بی‌روح و سنگی؟!

بیا یک بار دیگر
به فکر بچّه‌ها باش
بخندان ابرها را
کمی مهمان ما باش

حریر تازه‌ات را
بپوشان بر تن دشت
بخوان با شادمانی
که رنگِ رفته، برگشت

بیا و عطر بازی
بپاشان روی کوچه
دوباره های و هویی
بپا کن توی کوچه.

۱۵

81

زندگی اگر این بود
نیست بود و بیهوده
زندگانیِ ما بود،
قصّه‌ای غم‌آلوده

مثل بوته، بعد از مرگ
عمرِ بهتری داریم
در بهار رستاخیز
رشدِ دیگری داریم

بوتهٔ بدی، حتماً
میوهٔ بدی دارد
خوش به حال آن کس که
بذرِ خوب می‌کارد

82

بهار قیامت

بوته‌ای که می‌میرد
بارو دانه‌ای دارد
باز دانه را دستی
توی خاک می‌کارد

مرگِ بوته هرگز نیست
عمرِ بوته را، پایان
مثلِ آن، پس از مُردن
زنده می‌شود انسان

83

PUBLISHING IN IRAN

Publishing in Iran

CHARLOTTE NORUZI

In a way, I've created a small window for myself through which I can "see" my country, a place that has been a mystery, kept secret and separate in my mind. My collection of children's books triggered my sense of curiosity, a desire to know what things are like in Iran now and the need to reconnect with where I am from. I wanted to lift the veil a little and see what's underneath. I wondered what books were like. What was the publishing climate like now? What was it like to be an illustrator, publisher or artist now as opposed to pre-revolution times? How have things changed? Was their more expression, less? How had the ever-present hand of censorship played a role? I posed these questions to a handful of people I contacted living and working in Iran, among other places. Roots to my country that were severed so long ago seemed to come alive again with every person I talked to.

The people of Iran have always lived censored lives and the struggle and desire for expression is an old one. Censorship has gone hand-in-hand with art and words. Something is expressed, let out and then suppressed, driven back in. This dynamic is an essential ingredient of the country's history and is never more evident then in the visual arts and publishing. Ali Reza Mostafazadeh of the design firm 5th Color states, "Ban on publication has always been present in Iran, since the existence of the very first print/publish houses and has been due to the government's complete domination of social matters and policies." Throughout the 20th century, numerous publishing houses would open and quickly be shut down by the government if the government felt it had been misrepresented. Newspapers and magazines had to contain this pro-government angle or face forced closure and the imprisonment of its editors. Forbidden books carried white covers to thwart suspicion. Nahid Rachlin, acclaimed author of *Foreigner*, relays in her memoir, *Persian Girls*, how reading these forbidden books was a dangerous pursuit, for readers and vendors. The bookstores that dared carry them were in constant danger of being raided. Rachlin explains that censorship was just as bad under the Shah as it is now in the Islamic Republic, the difference being mostly in what was censored. Under both regimes, any anti-government sentiments were banned, but the Shah's Iran also banned anything that seemed Communist in nature and therefore Russian books were censored. Another mandate was that Iran had to be portrayed as flawless, beautiful and clean, like a diamond, with happy and satisfied people walking down glittering streets. A passage in a book that presented unclean streets or a depressed person — essentially painting a realistic picture — was unacceptable. The Shah's utopian vision projected a society onto the world free of crime, dirt and suffering: a superficial prosperity.

Although people were taking advantage of the modernized aspects of Iranian life that the Shah was instilling, there was no real push for improvement in or ambition toward education. Toward the end of his rule, mostly through the efforts of his wife, Queen Farrah, attempts were made to activate reform, particularly for women, such as the Family Protection Law, concerning custody and abuse issues. But as Rachlin poignantly states: "You can't change a whole country's tradition."

Change takes time. Laws were not enforced as the lawmakers were extremely conservative and did not want to empower women. So in turn the daily lives of women, in particular, went more or less unchanged. With the Islamic revolution came the reinstatement of the mandatory wearing of the chador. Forcing women to hide their femininity further suppressed the natural desires between people. Publishing reflected this with moralistic guidelines: writing that mentioned sex or alcohol was prohibited, even a description of a couple holding hands. What did change under the new regime was a woman's economic role. Under the Shah, a woman's role was essentially domestic, with the man solely fulfilling the role of breadwinner. In the wake of the revolution and the economic devastation of the Iran-Iraq War, more opportunities became available for women to be educated and work and make money. "Economically," Rachlin adds, "out of sheer necessity, women are needed in the workforce. Some men hold down 2 or 3 jobs, in addition to their wives working, just to make ends meet." Iran has also seen a large number of women attending university, educating themselves in far-exceeding ways. "In recent years," a young designer and illustrator by

88

Illustration from *Acko*, Haleh Ladan

the name of Golbarg Kiani explains, "more women then men are studying visual arts and these numbers grow every year to the point where there are sometimes virtually no men in the classes!" It is no wonder then that there are new regulations being set that will limit the number of women and mandate a certain percentage of men in the sciences and the arts.

Haleh Ladan, a gifted and seasoned illustrator, has the perspective of history as her vantage point on this subject. When asked about her opinion of how it is for women in the arts today, she answers: "It is more difficult for women to become 'real' artists, to be taken

Illustrations for *Little Red Riding Hood* (top and middle) and *Shahnameh* (bottom), Haleh Ladan

seriously." Despite hardships and obstacles, however, Ladan persistently pursues her passion and career in art. She goes on to say: "The quality of text severely diminished after the revolution and the beauty and 'strength' of story-telling and imagery also declined." There are fewer influential writers today, as there once were in the past. She refers to the past as the "golden age" of commissioned art and writing, the period (in the 1960s and 1970s) in which Kanoon thrived. Much illustration work was commissioned during this fruitful and successful period.

Farideh Khalatbaree is the founder, chairman and managing director of Shabaviz, an award-winning, successful children's book publisher in Tehran. The company was started in 1984 as a response to the deadened value of art. "It was [at this] time," Khalatbaree explains, "when Shabaviz decided to revive the art of illustration, book design and in fact children's book production in Iran. The result is what we have today. Everything has improved and we are today far better even than yesterday in every aspect." Shabaviz's titles consistently attract recognition and win awards internationally; the books are translated into over 50 languages, available in over 30 countries. This is owed in most part to the high standards they set for the authorship and illustrations and the production quality of the books. She does, however, remember a time when this was not the case. In empathy with Ladan's sentiments stated earlier, Khalatbaree adds, "Thirty to forty years ago was the turning point of children's books. Books produced those days were of high quality and won many international awards at that time. But then we had a big stop and a turn backward. At one time, we couldn't even name one single book comparable with international titles." I asked Khalatbaree what she thought the cause of this "regression" was. "Maybe," she replies, "because Iran is not a member of [the] copyright treaty and it is always cheaper and easier to re-publish what has already been printed in other countries. There was also no merit for producing high-quality illustrated books and no support."

Ladan believes the numbers dwindled as a result of the revolution and the Iran-Iraq War. Then after several years, as the direct effects of the revolution and the war receded, art began emerging again little by little. Ladan remarks, however, that even now, the general "weakness of quality" of the work coupled with a generally inactive market and disinterest in investing in the publishing of children's books from within the country, creates little demand for the commission of illustration. Illustrators are looking to publish outside of Iran as a result. Better print quality is ensured and there is a much broader chance of getting known.

Ladan and Kiani both agree that currently a great deal of Iranian illustration is seen in art festivals, especially foreign festivals. The aspirations of Iranian illustrators for attention and recognition are aimed toward venues outside of Iran. Ladan further explains that Iranian illustration is heavily influenced by contemporary work done outside the country and that Iranians are shaping their work to fit those tastes. In Ladan's approximation,

"IRAN HAS ALWAYS LOOKED OUTSIDE FOR IDENTITY, NOT REALIZING THAT IT HAS ALL THE MEANS WITHIN. THIS 'LOSS OF ORIGINALITY' IS A CONSEQUENCE OF THIS MENTALITY."

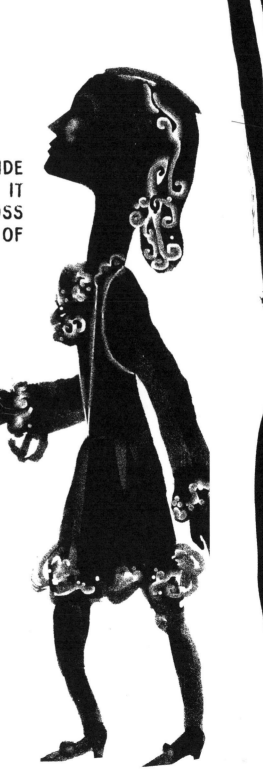

"everything starts looking the same." Illustrators are too busy contending for awards at these competitions and this in the long run can only damage the originality of Iranian illustration. Kiani adds that illustrations of years past were imbued with originality, which is lacking in current work. I add to this by saying that Iran has always looked outside for identity, not realizing that it has all the means within. This "loss of originality" is a consequence of this mentality.

I also spoke with Farshid Shafiei, a talented contemporary illustrator, about artistic restrictions. Asked if he sees a difference in the "quality" of the art or writing in books for children or young adults, Shafiei commented that the writing especially had been effected and is "behind" in terms of quality. Censorship takes a huge toll on what is acceptable language, the Ministry of Culture going so far as to recall books for re-inspection, although they had already been published. These restrictions generally are moralistic in nature, but the overall randomness creates the most frustration among visual artists. There is no "law" to the law. Writing, once vibrant,

Farshid Shafiei

(Continued on page 94)

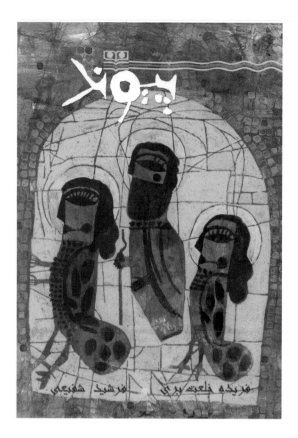

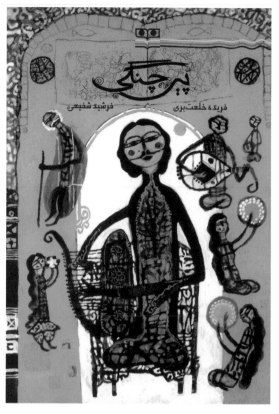

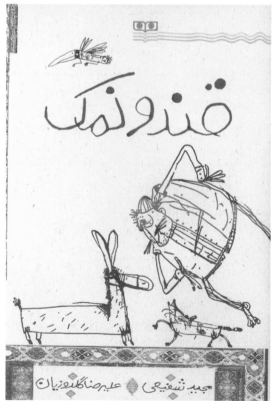

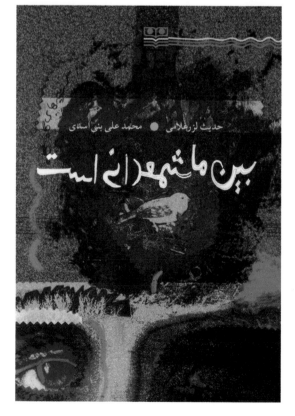

A selection of book covers from the publisher Shabaviz. Page 92 (clockwise from top left): *A Link*, Farshid Shafei; *The Old Lyricist*, Farshid Shafei; *There are Geraniums Between Us*, Mohammad Ali Baniasadi; *Sugar and Salt*, Ali Reza Goldouzian. Page 93 (clockwise from top left): *Love Stories*, Atyeh Bozorg Sohrabi; *The Sound of Little Green Goats' Footsteps*, Marjan Vafaeian; *Wolves and Humans*, Saba Maasoumian; *The Fox*, Amir Shaabanipour.

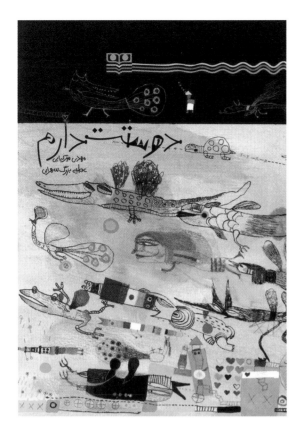

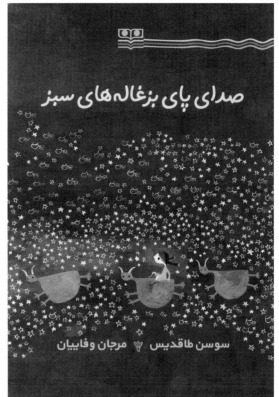

صدای پای بزغاله‌های سبز

سوسن طاقدیس ❧ مرجان وفاییان

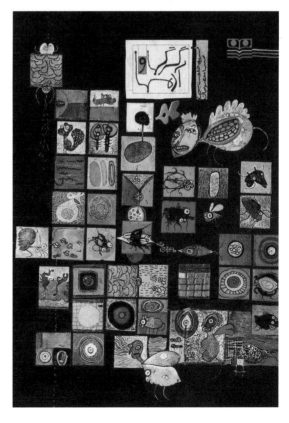

diverse and distinct, is filtered through a sifter, "refined" and losing its raw energy, its natural form, converted into something more sterile, more "clean." I imagine censorship like a lawn mower, neatening the unruly grass. Like a pair of hedge clippers, creating well-trimmed topiaries out of the "wild" bushes. It seems to me that there is a self-inflicted "clipping" of originality on several levels in Iran. It is ironic to think that artists are conforming their art in order to stand out and be recognized. Although Shafiei's own work has been censored, the examples here do not, in my opinion, suffer from this "loss." On the contrary, his work brims with a positive, energetic quality, steeped in culture but up-to-date, which I believe is desperately needed to counteract mediocrity.

Khalatbaree shed even more light on the subject of censorship: "Censorship is making life more difficult every day. It is not just censorship but new unbearable rules and regulations are preventing good production. The most harm is done by government's unconditional support of some publishers and neglecting the others. Government publishing houses are most harmful, too. The pressure on private publishers like Shabaviz is too much but there is nothing we can do at home. We are trying to survive in a closed market where all the schools, libraries, public purchases and even big bookshops are controlled by the government, government publishing houses or even the so-called private-looking government publishers. To give you a better picture, I should mention that our first print run in 2000 was 12,000 copies and in 2007

94

(Continued on page 96)

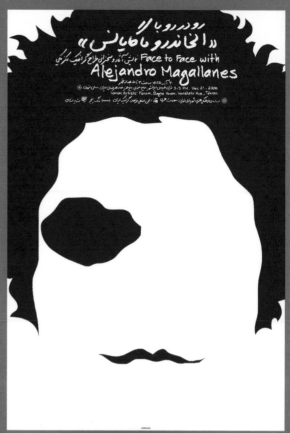

Poster designs by Alireza Mostafazadeh

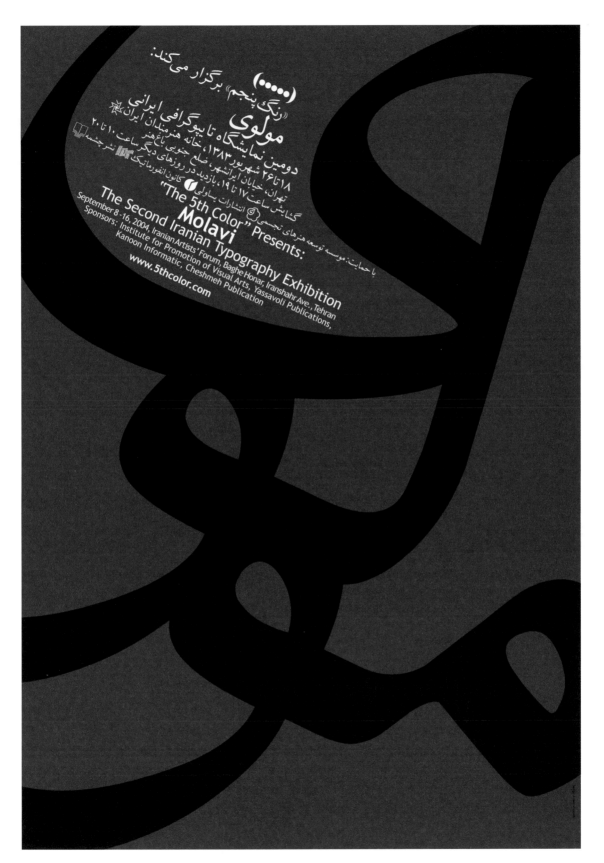

"IRAN'S REVOLUTION, LIKE ANY OTHER ONE ACROSS THE WORLD, TRANSFORMED MOST SOCIAL ETHICS; ART WAS A CONSEQUENCE OF THIS AS WELL."

was reduced to 2,000 copies only. This is because day by day the market is getting tighter for private activities. The main buyer of children's books is the government and they buy for exhibitions, for libraries, for schools and many other similar purposes. They only buy from themselves or their private-looking publishers."

It's no surprise then that Iranian artists are looking internationally for the recognition they deserve and it seems that they'll do whatever it takes to get it, even if it means compromising the integrity and distinctness of their work.

Despite all of this, there are those who feel that movement is toward distinction and individuality. "Nowadays," Mostafazadeh states, "these [restrictions] are more according to today's rules and policies. Iran's revolution, like any other one across the world, transformed most social ethics; art was a consequence of this as well. In graphic design a downfall happened, which was the cause of 8 years war with Iraq and continued until the end of it. But after the war some positive changes happened in the political and social atmospheres of Iran, which began a new stage [of graphic design] and still is moving ahead with its specific distinctiveness." Khalatbaree utilizes this distinctness, with each of her books having "its own special graphic design."

The strong pull of tradition will always exist against the momentum of progressive thought, of moving forward and beyond restraints. Part of Iran's tradition has been a denial of reality. This can be witnessed under both regimes. But I don't believe you can hide that reality in art. Art, on one level or another, reflects it, for better or worse. Several "realities" have been presented here of varying viewpoints but by no means does this essay reveal a comprehensive view. Instead it is a personal look. A look that has inspired further questions for me, that transcend these particular individuals, speaking to the greater notions of art's purpose and how that purpose is defined. How does the definition of that purpose, or of art for that matter, inform how people express themselves, and what are they trying to express? Is it self-expression or some semblance of an idea of what the expectation of expression should be? Is it a means to communicate an internal struggle? Do commercial commissions fulfill self-expression? Is there a higher purpose in creating art?

Perhaps it is the only way to survive, a means of making sense of the chaos of everyday life. Perhaps a response to tradition, having the power to transcend it. Nevertheless, it seems that through the cracks in the cement laid down time and again (by the various regimes), seeds of expression and creation sprout and flourish despite the dim oppression that surrounds and stifles. For whatever reason we choose, our nature is to create and express, not suppress, and despite severe restrictions on their freedom, authors and artists continue this tradition. ☺

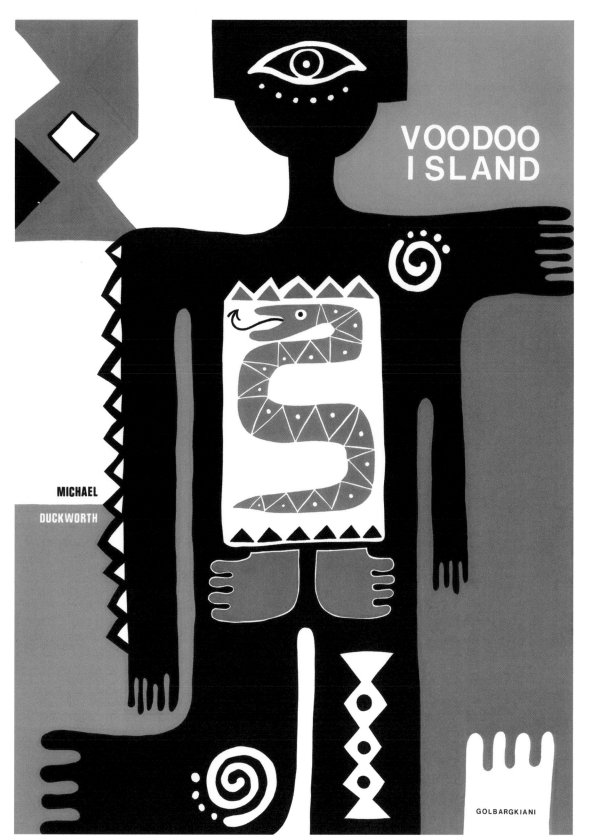

VOODOO
I SLAND

MICHAEL

DUCKWORTH

GOLBARGKIANI

Book cover for *Voodoo Island* by Michael Duckworth. Golbarg Kiani

 OTHER ILLUSTRATORS

100

101

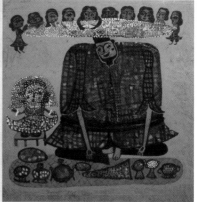

102

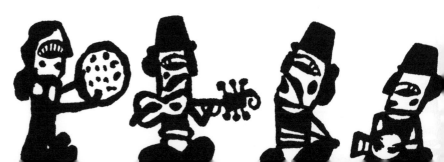

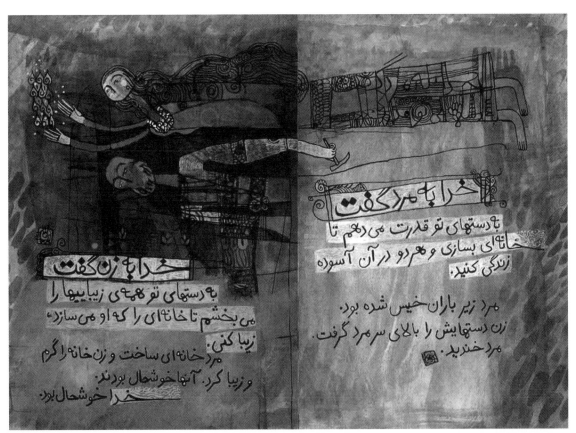

خدا به مرد گفت
به دستهای تو قدرت می دهم تا
خانه ای بسازی و هر دو در آن آسوده
زندگی کنید.

مرد زیر باران خیس شده بود.
زن دستهایش را بالای سر مرد گرفت.
مرد خندید.

خدا به زن گفت
به دستهای تو همه ی زیباییها را
می بخشم تا خانه ای را که او می سازد،
زیبا کنی.
مرد خانه ای ساخت و زن خانه را گرم
و زیبا کرد. آنها خوشحال بودند.
خدا خوشحال بود.

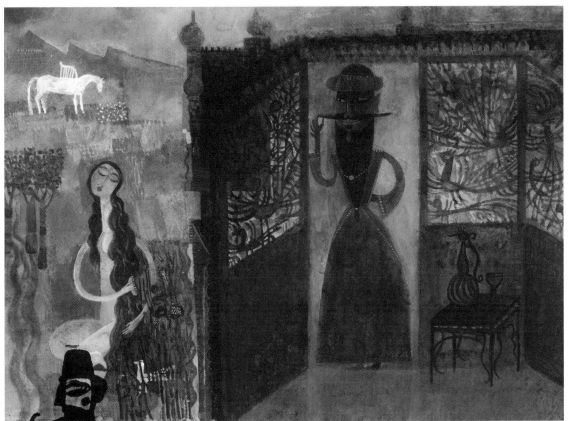

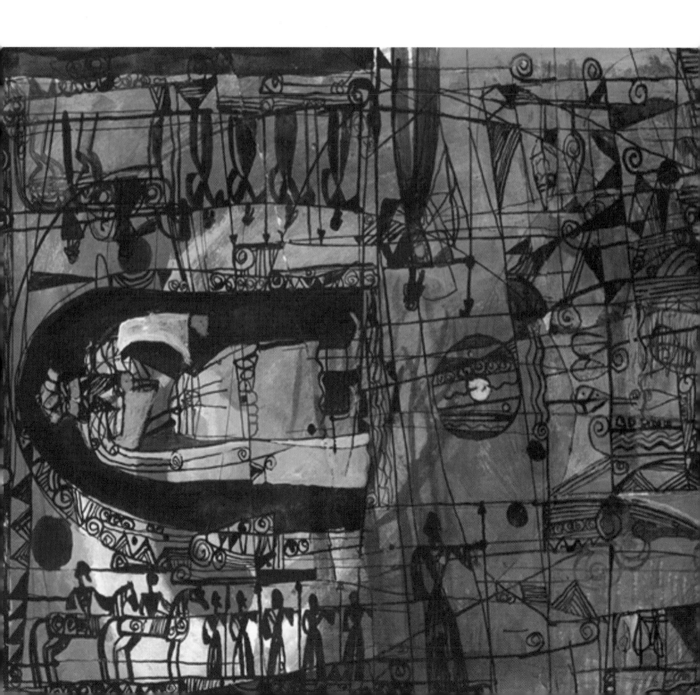

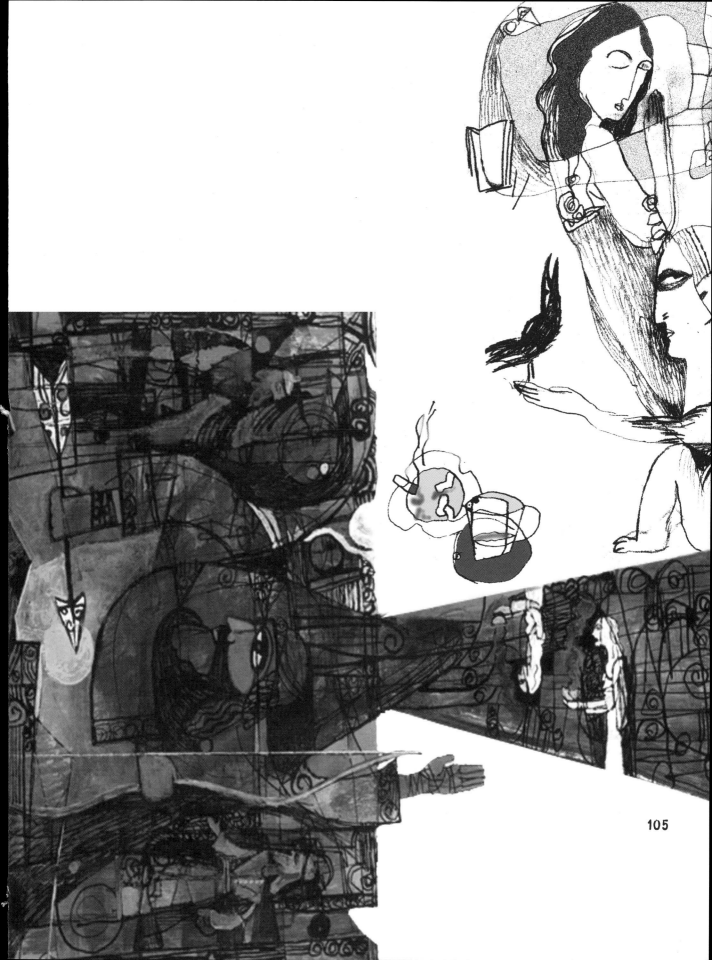

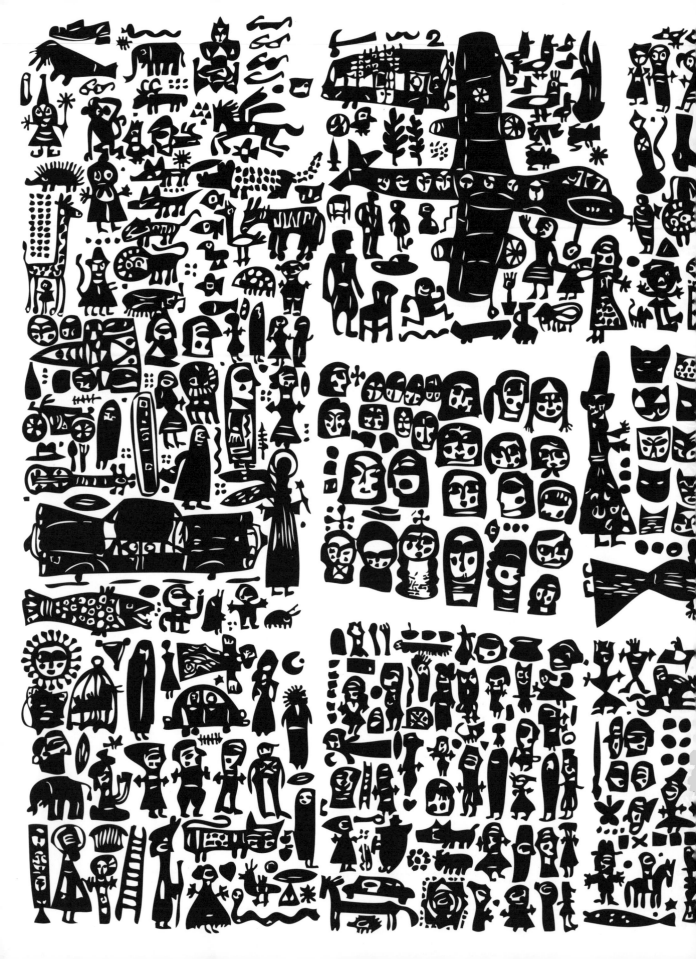

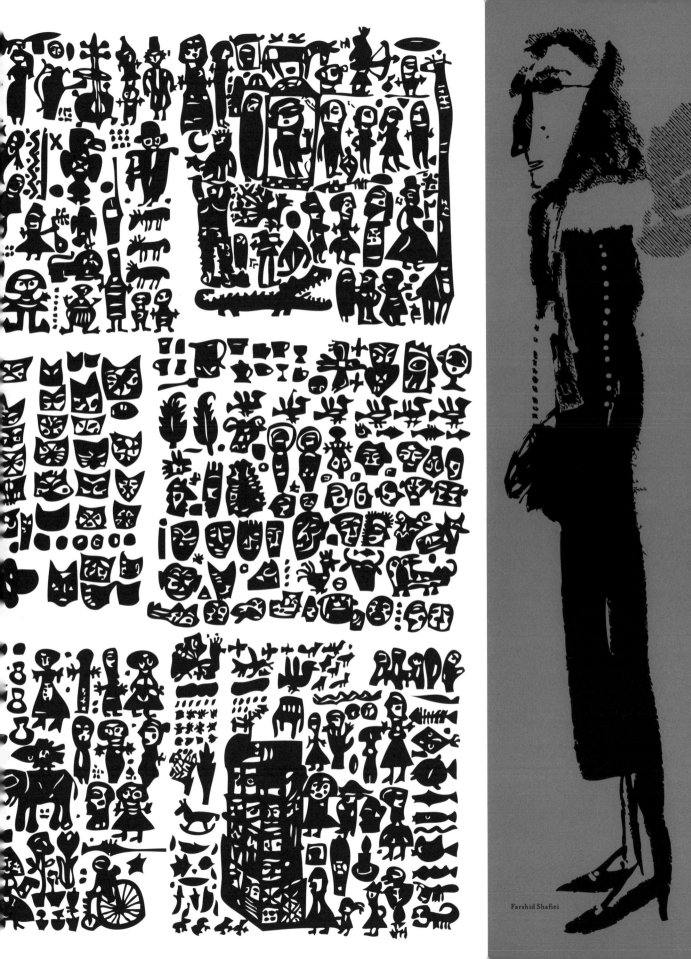

Farshid Shafiei

Sahar Hagigoo

113

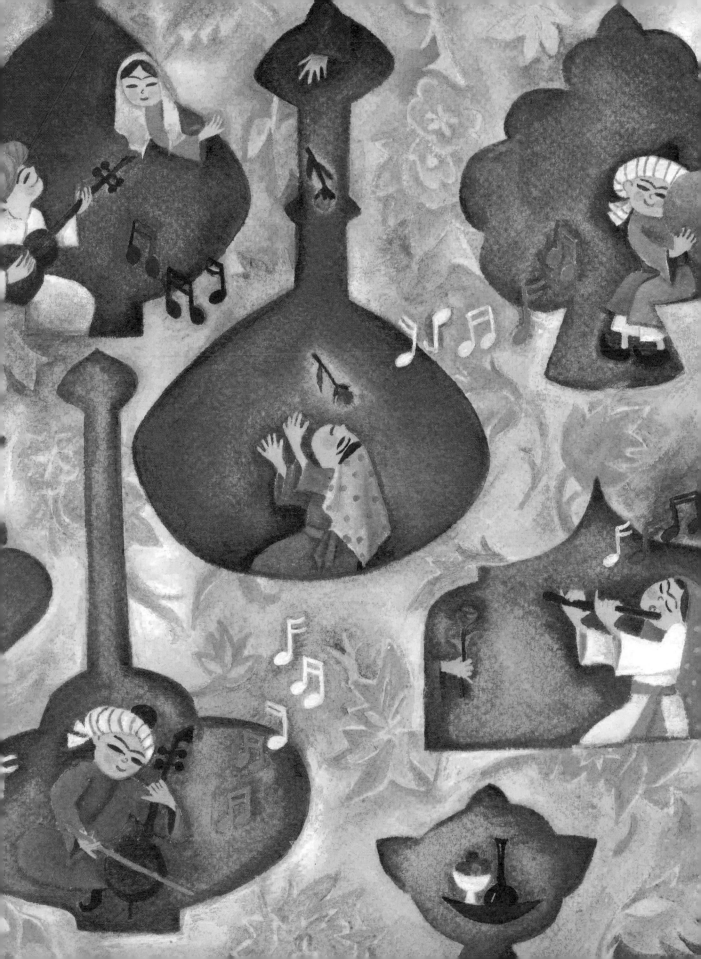

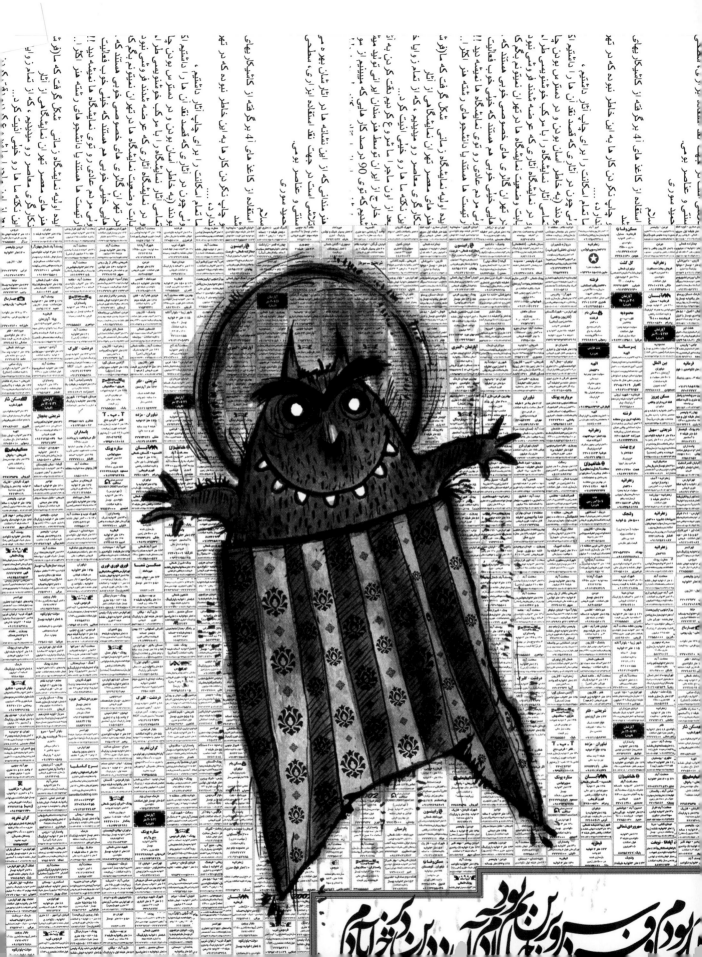

EXOPALASHT

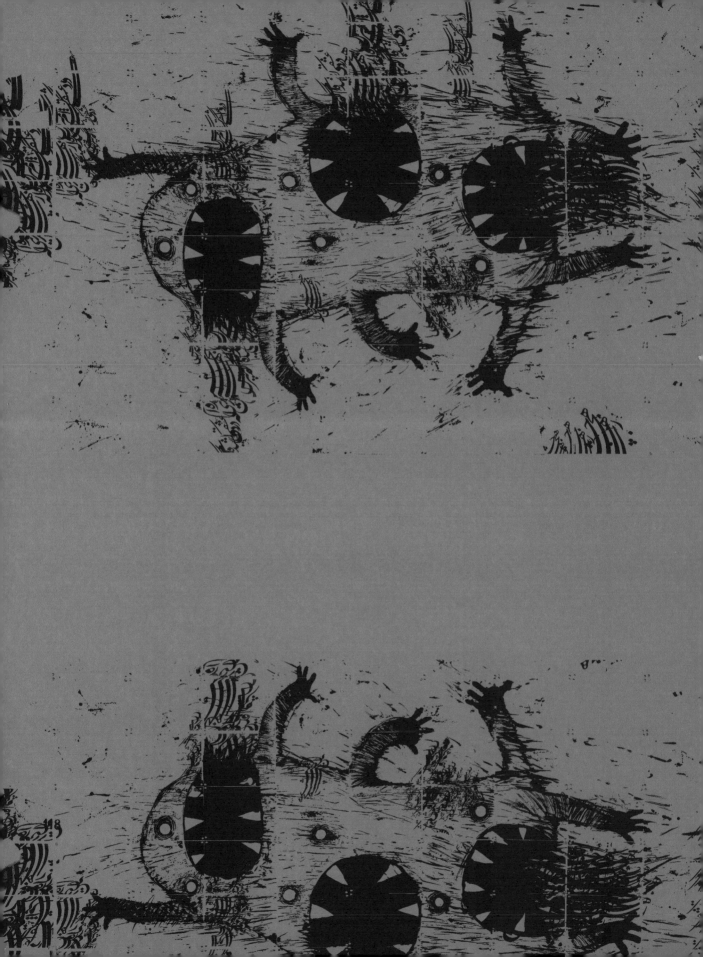

Exopalasht

CHARLOTTE NORUZI

Farshid Monfared and Pooya Abbasian are the two young Iranian artists who created "Exopalasht," exhibited in Tehran in October 2007. "The word Exopalasht," Monfared explains, "is made up of two words: exotic and *palasht*, the Farsi word for 'unclean' or a bad thing, a monster." These monsters "take flight" in the artwork as the winged *div* or *gen* of Iranian folklore, known for their mischievous antics, voracious appetites — they eat anything — and their frightening demeanor. As a child I remember being threatened with these demons if I misbehaved. They feel like uninvited guests wildly disrupting an otherwise peaceful scene, the status quo.

The idea for Exopalasht started to take shape after the two men visited the Tehran Museum of Modern Art. The trip raised the question as to what contemporary Iranian art really was. As they see it, the current trends in Iran seem to be derivations and emulations of Persian miniatures. "The works displayed were not only bad, but laughable," Monfared explains. "This bothered us quite a bit. From then on we started paying attention to contemporary works produced by Iranian artists inside and outside of Iran. We noticed that in ninety percent of the works, Iranian motifs and calligraphy have been used without any seeming purpose or any knowledge on the part of the artist about the backgrounds of such images. It appeared that the motifs were being used only to quickly grab the attention of non-Iranians, as there is a thriving market for such things." This seems to be the driving trend in Iranian art today, but is it really art? Monfared and Abbasian do not think so: "Our issue is not so much the use of such motifs. Rather, what we question is the false and trivial use of these motifs, not to mention the reaction of people outside of Iran [to] contemporary Iranian art and artists because of it."

Exopalasht was a response to and a critique of this. The exhibition is essentially a series of murals, with the images made up of hundreds of tiled pieces of A4-sized paper. Borrowing from the signature element of tile work, Monfared and Abbasian have modernized the tradition. And although they had all the means available to them to print the pieces traditionally, in the spirit of their criticism, they decided to hang originals, done in pen and ink.

The following text is taken directly from the exhibition's program, providing further insight in the words of the creators:

For a while now certain Iranian artists have been using native (Eastern, Iranian, Islamic) cliché images and elements in order to draw the attention of outsiders to their works. Since such productions happen to not only satisfy the latter's thirst for the exotic but to also compliment their preconceptions, the works in question have received quite a bit of attention. The point is neither to disregard the value of such motifs nor to indict all of the artists who make use of the said representations in their works. Rather, the works in this exhibition are meant to be an effort in critiquing the shallow and superficial use of traditional images. — Hamid Severi, October 2007

In the poster "Peace for All" (see page 122), the menacing but playful devil is releasing a white dove. In another rendition though, it is eating it. Humor, irony and satire are used to comment on the state of world affairs or the state of art in Iran. I add my own interpretation by saying how this piece makes me question the sacred, reveals the profane within the deeply religious and, in some pieces, brings sexuality to the forefront of a very conservative and moralistic society. My favorite is the mutant triplet monster that is belching forth calligraphy. Asked about the significance of this piece, Monfared says: "There is really bad calligraphy being done today, specifically in graphic design, without thought or knowledge of the rich tradition of this art form." The monster is rejecting this misuse as if to say, "Stop feeding us this garbage." They don't want it in their system.

Another intriguing piece is the monster with a halo around its head painted onto the classified page of an Iranian newspaper. The page is specifically selling homes and office space. The quote by Hafez on the bottom right reads: "I am an angel and I belong in heaven, yet I have no home." This reflects the monster's predicament. Since there is no copyright law in Iran, people can take what they want from each other at will. The image of the "homeless monster" seems fitting with the predicament of artists, who are totally exposed, without protection or "shelter." As Monfared shed more light on the conditions in which artists work in Iran today, the powerful message of this piece became more evident to me.

There are very few venues for young Iranian artists to exhibit and equally little opportunity to sell their work. "There's not much to tell about galleries and exhibitions in Tehran, except to say that things are not good," Monfared laments. I hear the frustration and disappointment in his voice. He goes on to inform me that galleries are paid to exhibit artists' work but there are really no sales at an exhibition. There is also not enough of an audience base and therefore not enough interest or attention paid by Iranians living in the country. "One doesn't really see common folks at these galleries," he continues. "The people who visit are mostly gallery people themselves, or artists and art students." Older, established artists are selling but in only 2 or 3 well-known galleries that cater mostly to non-Iranian collectors. It seems that there is not enough emphasis and importance placed on art.

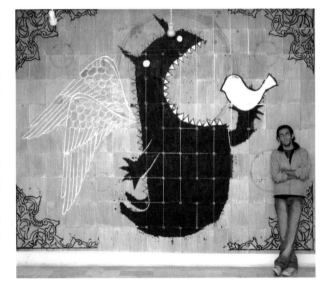

In speaking with Monfared about Exopalasht, I couldn't help but be reminded of something that the illustrator Golbarg Kiani told me: "In third-world countries like Iran has become, the thing that disappears first from people's lives are the visual arts because art is not taken seriously and seen only as a hobby." I believe this is a sentiment shared by Monfared and up-and-coming-artists of his generation. Evidently, awareness needs to be created around the new art forms and movements taking root, fronted by this fresh and visually vocal generation of artists. They want to be taken seriously. They have something important to say and want to be heard. Not only to fulfill their own expressions, but to help their fellow citizens fulfill their own. ☻

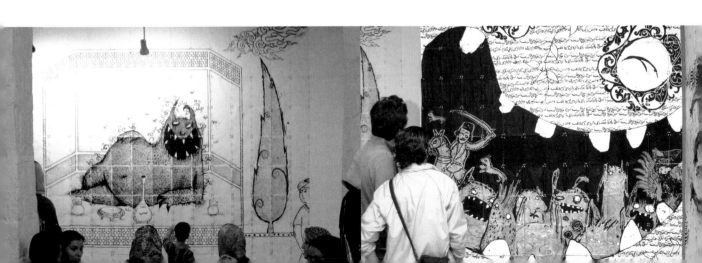

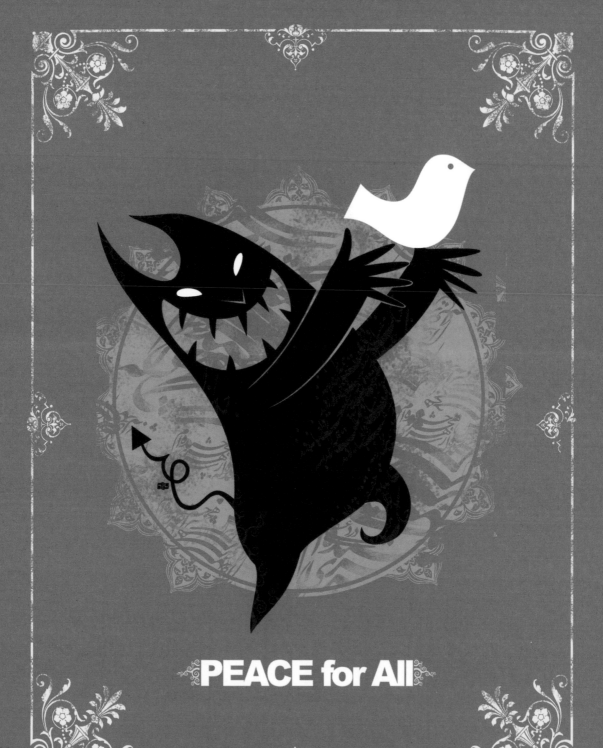

PEACE for All

BIDOUN IS AN ARTS ORGANIZATION
BASED IN DUBAI, CAIRO, AND NEW YORK,
DEDICATED TO SUPPORTING AND
PROMOTING CONTEMPORARY ARTISTS
FROM THE MIDDLE EAST.
ESTABLISHED IN 2003, THE ORGANIZATION
PUBLISHES THE AWARD-WINNING
QUARTERLY MAGAZINE BIDOUN, CREATED
AS A PLATFORM FOR IDEAS AND AN OPEN
FORUM FOR EXCHANGE, DIALOGUE AND
OPINIONS ABOUT ARTS AND CULTURE FROM
THE MIDDLE EAST. WE ALSO PUBLISH UNDER
THE IMPRINT BIDOUN BOOKS; COMMISSION
ARTISTS' PROJECTS; AND CURATE
EXHIBITIONS AND EVENTS.
SUBSCRIBE AT WWW.BIDOUN.COM

Author Bios

SALAR ABDOH

Salar Abdoh's novels are *The Poet Game* and *Opium*. His essays and short stories have appeared in various publications, including the *New York Times*, *Guernica* and *Bomb*. He teaches at The City College of New York.

BRIAN ACKLEY

Brian Ackley is a founding editor of *Bidoun*. Currently, he is working toward earning a Masters of Architecture at Columbia University in New York.

SINA ARAGHI

Sina Araghi is a photographer living in Los Angeles.

COCO FERGUSON

Coco Ferguson spent two-and-a-half years in Iran, studying for a Masters degree at the School of International Relations in Tehran, researching *Taziyeh* (the Islamic ritual theatre) and learning Persian. She left Tehran in 2006 and now lives in London.

SOHRAB MOHEBBI

Sohrab Mohebbi has a BA in photography from Tehran Art University. He founded the band 127 in 2000 and writes about art and music for *Bidoun* and various Iranian magazines.

CHARLOTTE NORUZI

Charlotte Noruzi was born in Tehran and moved to the U.S. in 1977. She is an artist-designer-art director and has taught graphic design and illustration at Pratt Institute, New York. Her autobiographical children's book, *Grow, Watermelon, Grow*, is a mixture of her Persian roots and her American upbringing. Her woven artist's book, *Lady of Shalott*, is in the permanent collection of the National Museum of Women in the Arts. She continues to explore her rich heritage, integrating it with her present identity, through the weaving of scarves, wall hangings and art-to-wear. Writing for and directing the design of *Urban Iran* has also contributed to a reconnection with her culture.
www.grow-watermelon-grow.com

grow watermelon, grow

written and illustrated by charlotte noruzi

KARAN RESHAD

Karan Reshad, founder of Tehran's Kolah Studio, is a photographer, writer, translator and advocate for the arts: kolahstudio.com.

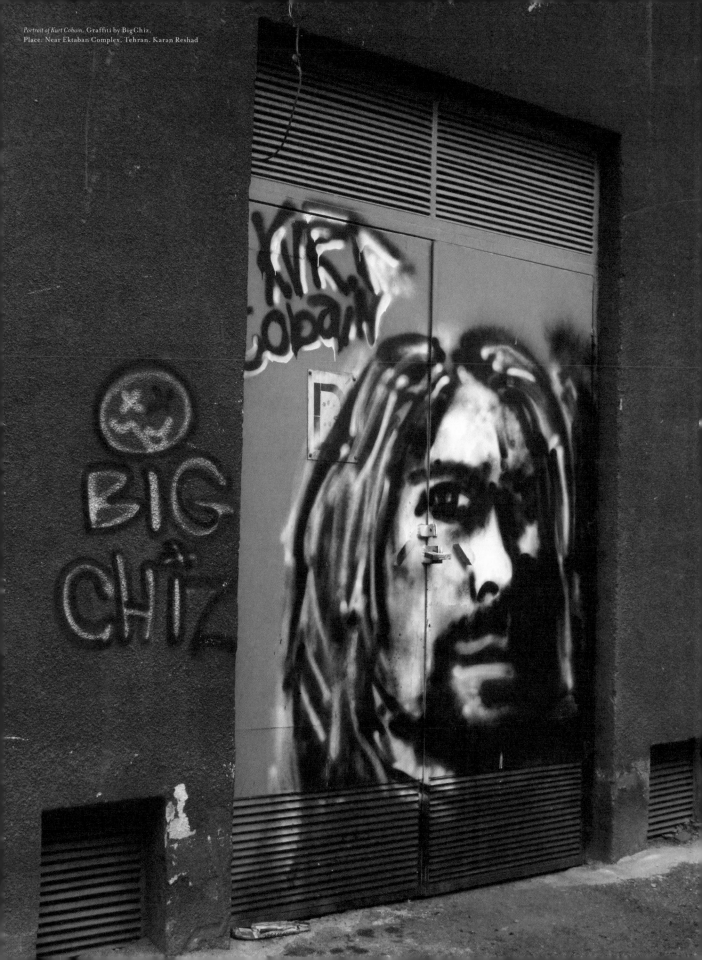

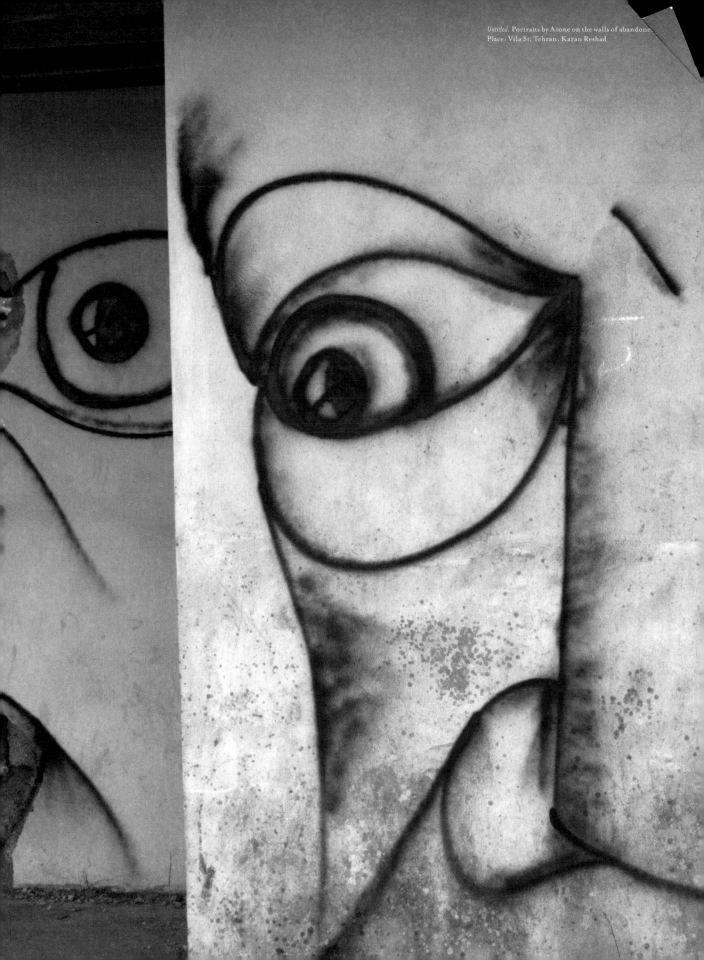

Untitled. Portraits by A1one on the walls of abandone.
Place: Vila St, Tehran. Karan Reshad